PAINTING COMPOSITION

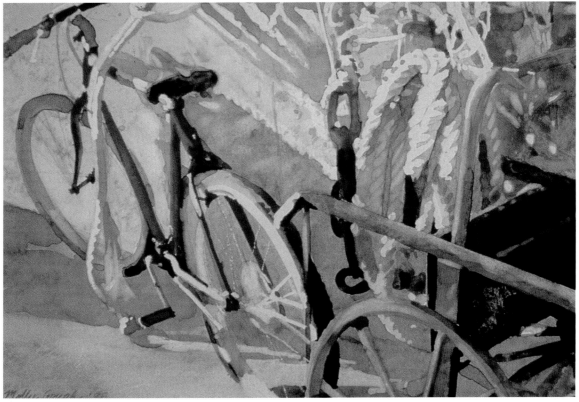

Italian Textures–*Molly Davis Gough*

First published in the United States of America by:
Quarry Books, an imprint of
Rockport Publishers, Inc.
33 Commercial Street
Gloucester, Massachusetts 01930-5089
Tel: (508) 282-9590

Distributed to the book trade and art trade in the United States by:
North Light Books, an imprint of
F & W Publications
1507 Dana Avenue
Cincinnati, Ohio 45207
Telephone: (800) 289-0963

Other Distribution by:
Rockport Publishers, Inc.
Gloucester, Massachusetts 01930-5089

ISBN 1-56496-370-5

10 9 8 7 6 5 4 3 2 1

Designer: Kristen Webster–Blue Sky Limited
Cover Image: *Sunlit Maple,* Edwin L. Johnson
Back Cover Images: *(Left to Right) Boats,* Ann Mitchell
End of the Day, Ara Leites

Manufactured in Hong Kong.

PAINTING COMPOSITION

selected by betty lou schlemm/edited by sara m. doherty

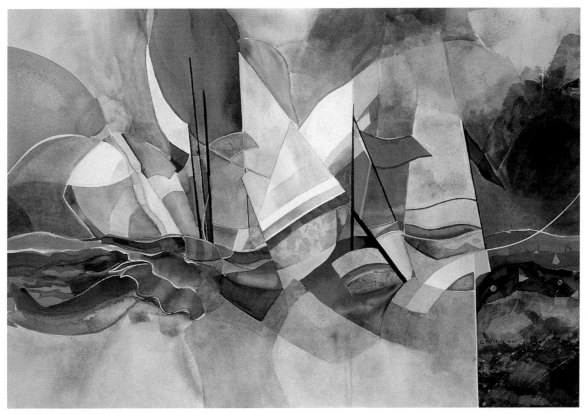

The Saga of Peter Grimes–*Gloria Paterson*

Quarry Books
Gloucester, Massachusetts

introduction

Composition is the most essential and most personal part of painting—it is the way an artist sees and reacts to the subject. Through careful observation, the artist and the subject become one.

It is from the close study of the laws of composition that we are able to be free. Free of and not hindered by them; after learning, we are able to put them in our deepest thoughts and move onward, working only from our emotion and subconscious.

Composition is more than just "putting the painting in a pleasing order." It is the way we begin to express ourselves, our feelings, the idea; through composition the idea takes a visible form. It is the balancing, the contrasting, the weaving of forms with each other. It is the division of the paper, the diagonals, horizontals, and verticals working together, expressing the intent and movement in our work. It is the dominance of color and value; it is the shapes and placement; it is the space to move through; it is the air itself. Composition is the tone of the entire painting: it holds the key to the mood. It is the painting itself, not being aware of the centuries, the schools, the masters, or the past. Though it comes from the past, it moves us forward to the future. Composition is the structure or skeleton that all work is built on.

The laws of composition can be learned by all, and creditable paintings can be made. But it is the addition of the spirit of the artist that truly makes a painting great. Without this one element, the work is merely a design, and not a true work of art.

The world around is us full of wonderful compositions. It is the artist, always looking, always with eyes wide open to observe, looking to see beneath the surface, to see the new way—their own way, how the arrangement of shapes and movement comes together and makes a personal, creative painting. It is our hope that his book stirs your imagination to new thoughts and new ideas; that it will inspire you to bring to your painting, through composition, something that will make it yours and yours alone.

Betty Lou Schlemm, A.W.S., D.F.

DEBORAH KAPLAN EVANS
Icarian Flight
30" x 23" (76 cm x 58 cm)
Arches 300 lb. hot press

I began by creating a montage from clippings and photos and then manipulated them to create a composition that appealed to me. As I moved the clippings about, I watched for interesting compositional lines that reflected the diagonals I am often drawn to. After transferring the design from a detailed drawing onto watercolor paper, I began to paint. Starting with the background, I used highly saturated color, wet-in-wet, and frequently sprinkled salt onto the wet paint. To create contrast and conflict, I introduced unrealistic colors and textures to create a generally photo-realistic look.

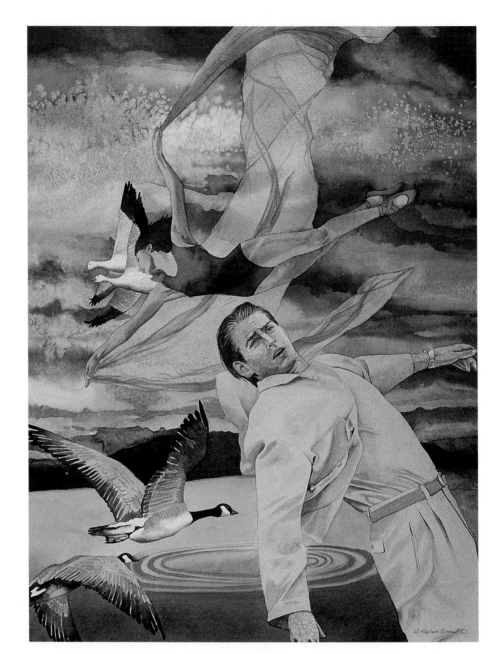

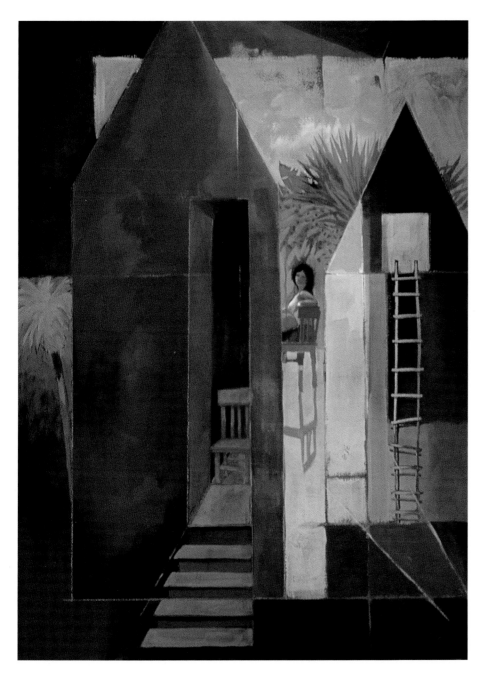

MICHAEL SCHLICTING
Waiting
30" x 22" (76 cm x 56 cm)
Arches 300 lb. cold press
Watercolor with gouache

A primary concern in my work is the expression of composition through value, shape, and movement. In *Waiting*, I sought emphasis on the architectural structure of the composition by drawing lines, extending shapes, and arbitrarily breaking up the picture's plane. This technique flattened the composition and emphasized the abstract qualities of the design rather than focusing on a literal description of the scene.

H. C. DODD
Web of Time
30" x 22" (76 cm x 56 cm)
Waterford 300 lb. cold press

Prior to painting, I construct a detailed mock-up that frequently takes days before I am satisfied with the composition. Because there is no recognizable subject, composition is of paramount importance. Using fragmented realism, I endeavor to create an abstract image with strong color and value contrast. The arrangement of color and value determines whether a painting succeeds in evoking the desired response in the viewer.

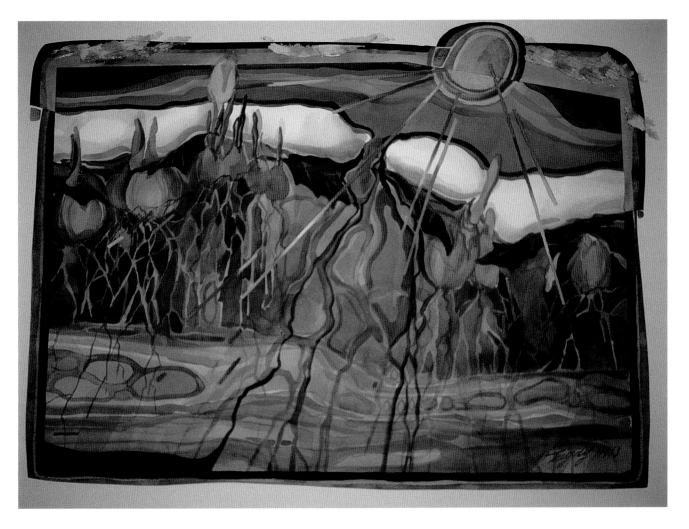

SUSAN WEBB TREGAY
Harbingers
20" x 28" (51 cm x 71 cm)
140 lb. cold press

Painted after a long, gray winter, *Harbingers* expresses the hope of spring through bright colors contrasted against predominant gray tones. The painting's border, along with rainbow-colored sunbeams created with the brilliance of watercolor, draws the viewer back for a second look at this expression of early spring weather in Buffalo, New York.

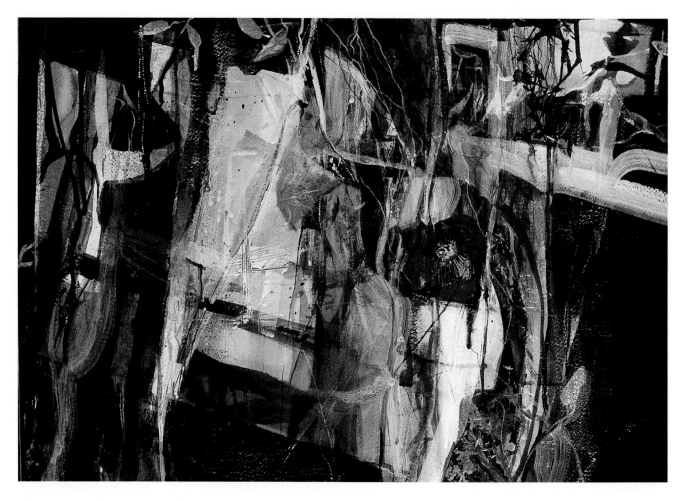

LYNNE KROLL
The Jewel
22" x 30" (56 cm x 76 cm)
Arches 140 lb. cold press
Watercolor with acrylic, gouache, ink, crayon, and pencil

My compositions are created spontaneously using experimental watermedia, which allows unique textures and rhythms to emerge as the work progresses. I use wet-in-wet, glazing, liquid pours, watercolor crayon resist, lifting, and spattering to create contrasts of dark and light, transparent and opaque, and sunlight and shadows. Tube acrylics applied with a broad foam roller, stencil stamps, and drybrush defined the shapes that suggest angular, stratified rock. Rock surfaces were further refined using thick titanium white that was then scored with lines and crevices. Textured rice paper was collaged and a hot-pink flower added to contrast with the existing elements.

PAT SAFIR
Green Onions
15" x 22" (38 cm x 56 cm)
Arches 140 lb. cold press rough

A dramatic composition was achieved by focusing on the subject and deleting everything unimportant in the background. Values range from the white of the paper to the darkest dark I could create. Crispness was achieved by 14letting each transparent watercolor wash application dry completely before adding another.

PHYLLIS HELLIER
Inside Out
30" x 22" (76 cm x 56 cm)
300 lb. cold press
Watercolor with gouache and ink

I design my paintings keeping movement, space, and value foremost in my mind. After transferring the initial concept from vellum to watercolor paper, gouache was used to preserve the light shapes of my image. Ink was then applied to the paper and once dry, the gouache was washed away, leaving the drawn image and producing an effect similar to a woodcut or lithograph. Colored gouache completed the work. The planes created in *Inside Out* help the viewer move between background and foreground, and then inside through the image for full access to the picture's plane.

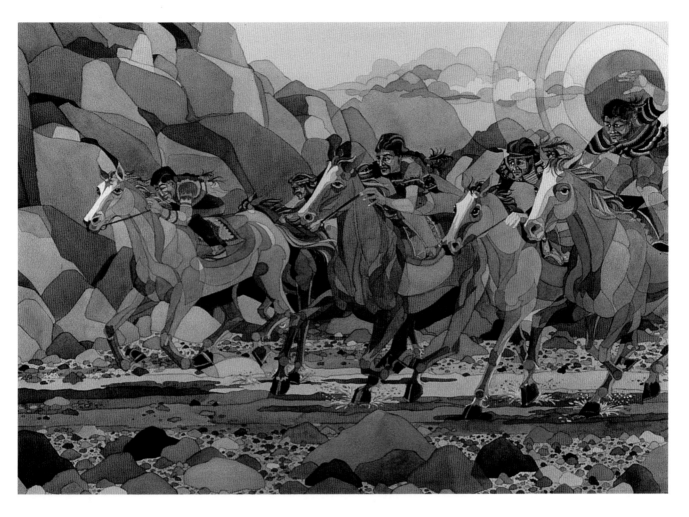

JOSEPH E. GREY II
The Race
17" x 29" (43 cm x 74 cm)
Arches 140 lb. cold press

The Race expresses the strong bond Native American boys have with horses. The full action of the work, along with the color of the rocks and the overall shapes, lends itself to the power of the composition. Color makes a statement in an abstract way, creating patterns of juxtaposed color and building space and tension. My technique evolved through years of drawing and observing the unique blends of color scattered all around us.

ELENA ZOLOTNITSKY
Old Tavern
14.5" x 11.25" (37 cm x 29 cm)
Strathmore

Inspired by the European masters of the seventeenth and eighteenth centuries, I use different techniques to produce a variety of textures: drybrush strokes for wooden objects and transparent glazes for the richness and contrast of fabric and skin. *Old Tavern* represents the well-balanced composition that is key in accomplishing the desired effect of combining a traditional subject with the artist's unique vision of that subject.

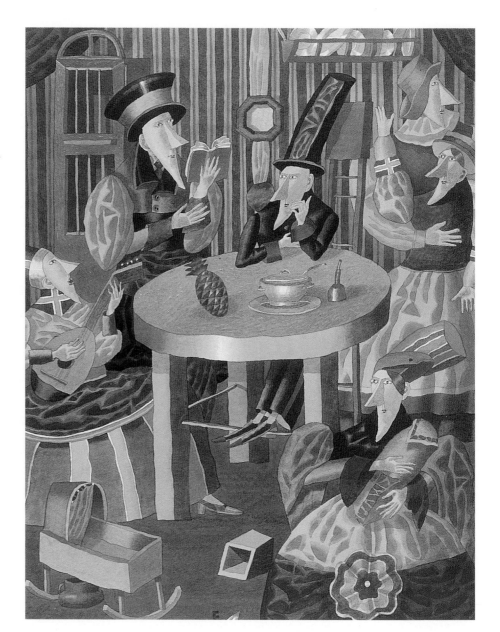

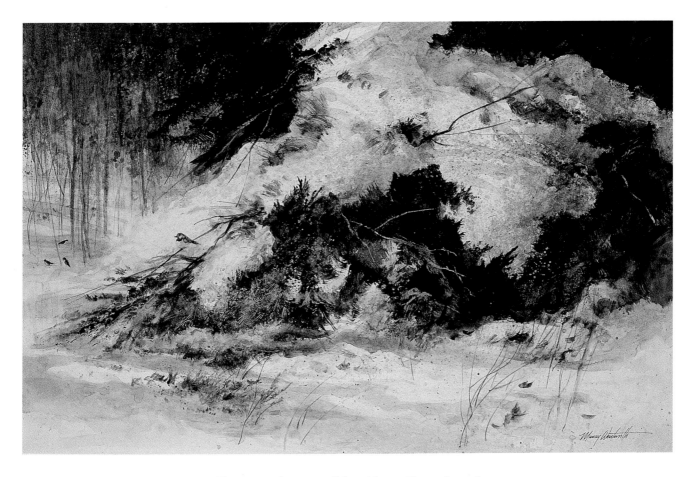

MURRAY WENTWORTH
Pine Boughs
20" x 30" (51 cm x 76 cm)
Strathmore heavyweight illustration
board smooth

The strong abstract qualities of the positive and negative space, especially in the snow areas, give dynamic movement to the composition. Smooth paper allowed for the creation of casual, but controlled, textures using techniques such as spattering and throwing paint. Some lifting using a damp brush and soft tissues was used in both the light and dark areas of the woods and snow. White shapes working around the darks are the most important element of the painting.

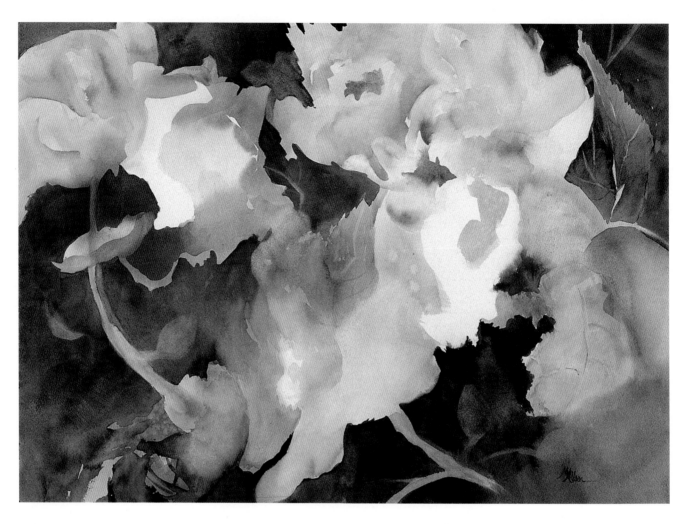

MELVA I. ALLEN
Parfait Angel
16" x 22" (41 cm x 56 cm)
Winsor and Newton 140 lb. cold press

Many of my paintings use flowers as the subject matter, and my angel-leaf begonia provided the inspiration for this painting. For *Parfait Angel*, I used a cross-hatch compositional device on the diagonal that would create a circular eye movement when viewed. The hardest, roughest edges at the top were negative painted so the viewer's eye would be drawn to them. Soft, cool colors were used to create an overall glow and an overlapping effect can be seen in the flowers' configuration. Primary colors were used, mixing them on the painting, working wet-in-wet.

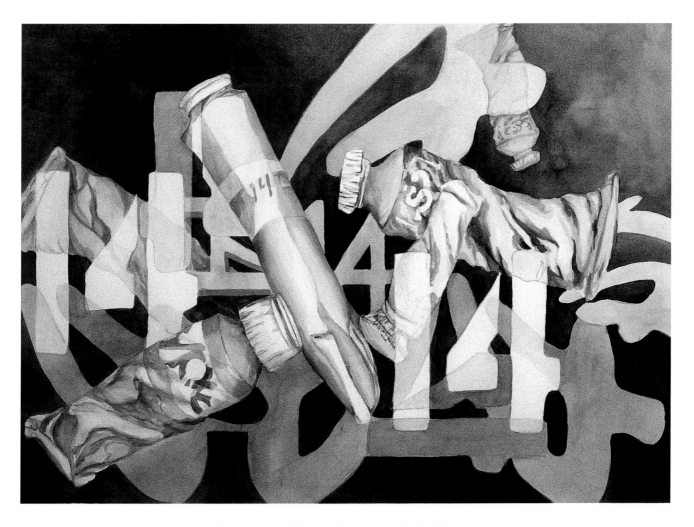

DONNA SHUFORD
14 Shades
22" x 29.5" (56 cm x 75 cm)
Arches 140 lb. cold press

Choosing an ordinary subject for *14 Shades*, I first made a small sketch of the paint tubes and then arranged them into a pattern of overlapping shapes. I enlarged the sketch on watercolor paper, adding more tubes and numbers to enhance the composition. A wash of black paint on wet paper darkened the negative shapes and when dry, glazes of grayed colors formed the shapes, emphasizing subtle changes in shades. The movement of contrasting values throughout the painting creates a rhythm of positive and negative shapes that produces an unconventional design.

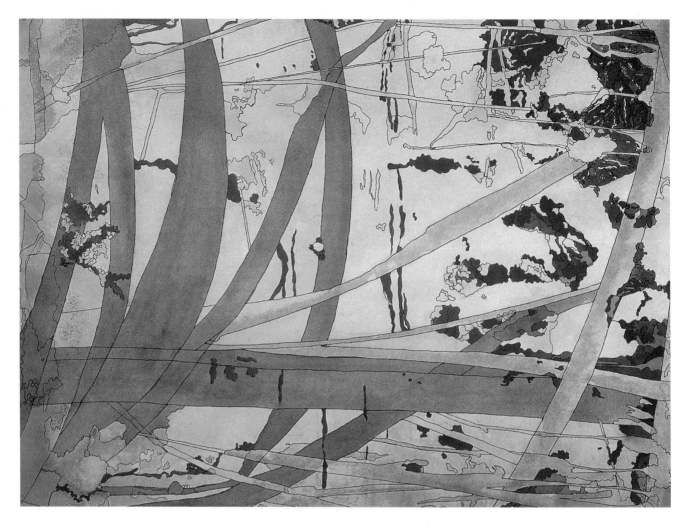

LORRAINE PTACEK
A Bridge to Cross
30" x 38" (76 cm x 97 cm)
Arches 140 lb. cold press
Watercolor and ink

The subject of *A Bridge to Cross* emerged as the work progressed. By pouring some colors and enhancing some shapes, I painted the bridge and the nature surrounding it. The intensity of the work grew as did my satisfaction with it. The movement of the shapes, the illusion of light, and the blending of the colors work together to create a composition that lets the viewer wander throughout the painting.

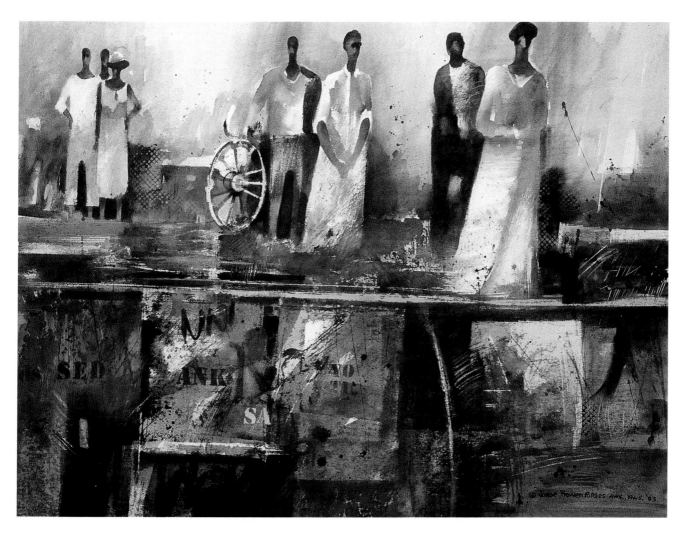

JORGE BOWENFORBÉS
Ancient Wall
30" x 40" (76 cm x 102 cm)
Strathmore cold press board

Using the repetition of related figures, I achieved the fundamental spatial element of the composition that suggests a backward movement of time and space. Rough sandpaper was dragged on the dried surface of the foreground figures, further enhancing the feeling of movement and space.

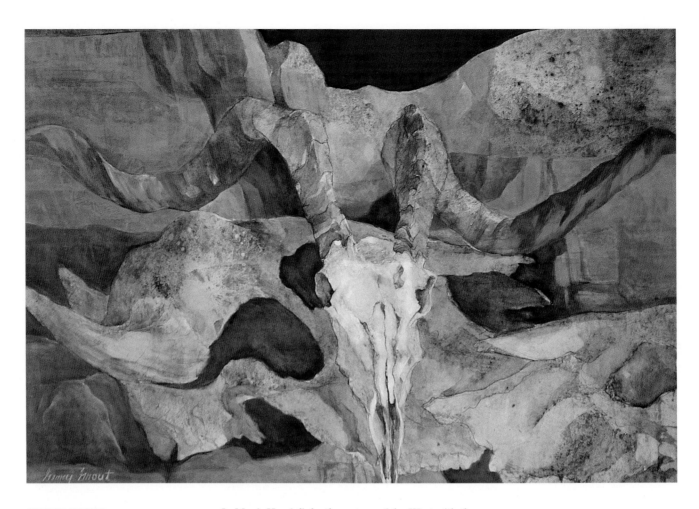

GERRY GROUT
In Man's Hands
22" x 30" (56 cm x 76 cm)
140 lb. hot press
Watercolor with powdered charcoal
and dry pigment

In Man's Hands links the nature of the West with the fragility of our environment. The texture was accomplished by sprinkling powdered charcoal and dry pigments onto hot press watercolor paper and then splashing with water. When dry, I arranged skulls from my collection to make an interesting composition. After a contour sketch was done, I finished with watercolor washes to suggest landscape forms in the background. Smaller dark values in and around the skulls lead the viewer through the composition.

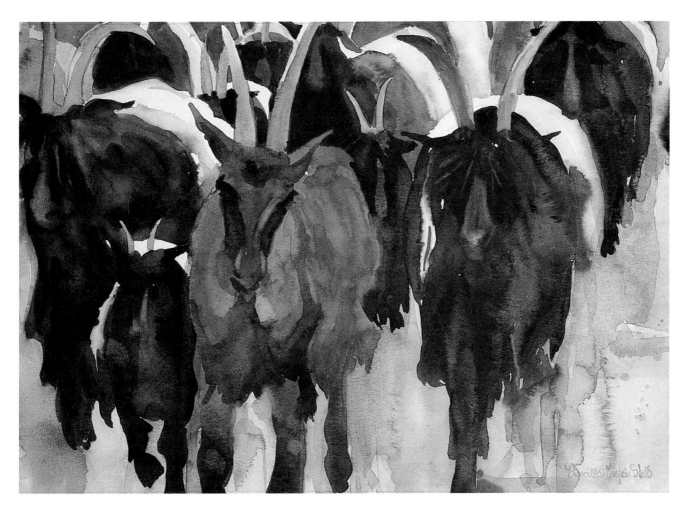

PRISCILLA E. KREJCI
Citizens of Zermatt
15" x 22" (38 cm x 56 cm)
Lanaquarelle 300 lb.

While in Switzerland, I was captivated by a herd of goats that had taken over the main street in Zermatt. As they paraded down the street, their movement created an interesting pattern of dark and light shapes. I concentrated on the movement of these shapes as I made my initial drawings, realizing the more realistic images of the goats as they came toward me. In the painting, I carefully followed my original drawing. To maintain the appearance of forward motion, I allowed the paint and water to form vertical shapes.

JOANNA MERSEREAU
Snowballs
28" x 14" (71 cm x 36 cm)
Saunders 300 lb. cold press

In *Snowballs*, I was interested in the semi-abstract quality of a flower arrangement. Composition and positive and negative space are all important to me and are usually worked out in line before I use color. Cold pressed 300 lb. watercolor paper is a reliable foundation for my technique of glazing brilliant washes laid over previous ones. The success of this painting is attributable to its composition and color.

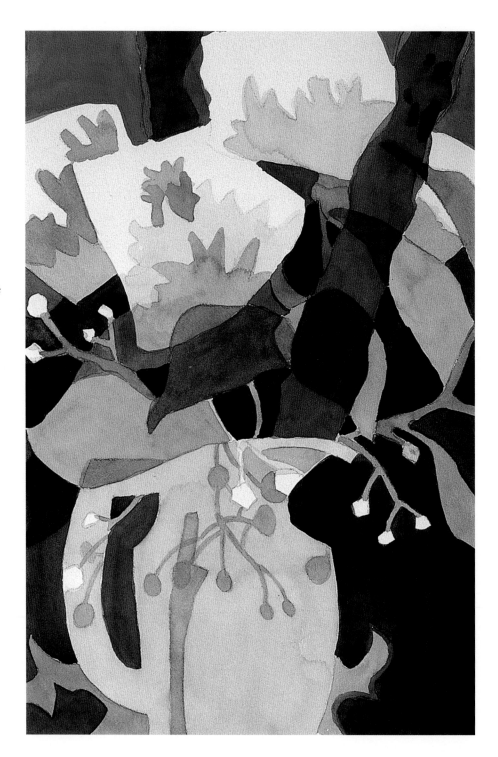

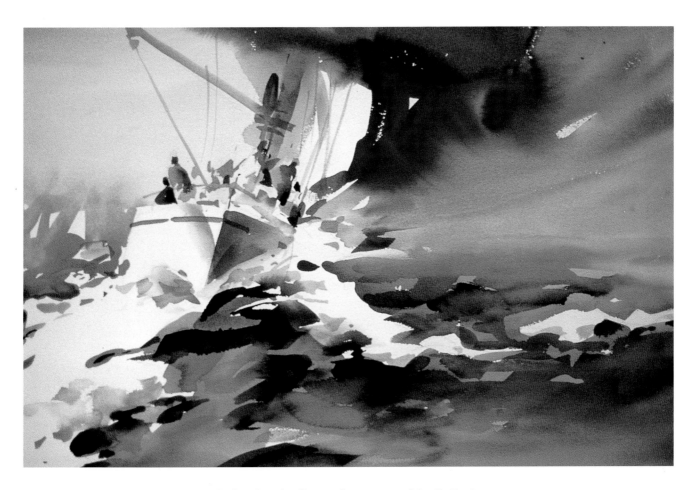

DOUGLAS LEW
The Red Sail
14" x 20" (36 cm x 51 cm)
Arches 140 lb. cold press

Rather than dwelling on the accuracy of details, I strive for an interesting and unusual division of shapes. I did numerous thumbnail sketches to achieve this effect in *The Red Sail*. Little was needed to suggest the subject matter as I sought to contrast the soft edges of the sails and the limited number of hard edges in the water. The sparseness of brushstrokes express force and lightness simultaneously, and I simplified and interspersed the white areas by connecting the waves to the boat, thus heightening the painting's visual effect.

BETTY M. STROPPEL
Daily Mail
30" x 11" (76 cm x 28 cm)
300 lb. cold press

The challenge of composing a still life in a long, vertical format was the inspiration for *Daily Mail*. It was necessary to use a bird's-eye view perspective and create a flowing movement of objects so the composition would hold together without appearing flat. A guiding principle of the composition was to utilize overlapping and color repetition to create a unity that moves the viewer's eye through the vertical plane.

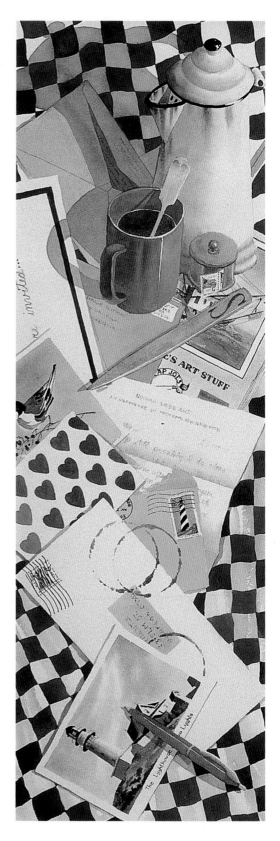

SANDRA E. BEEBE
Tribute to T. N.
22" x 30" (56 cm x 76 cm)
Arches 140 lb. cold press

In striving to accurately reflect the character of Tom Nicholas' palette, I based my composition on his method of establishing order out of chaos, while expressing my own vision and sense of organization at the same time. Striving to be faithful both to Nicholas and myself, I delved into both of our minds and artistic purposes on the most fundamental level.

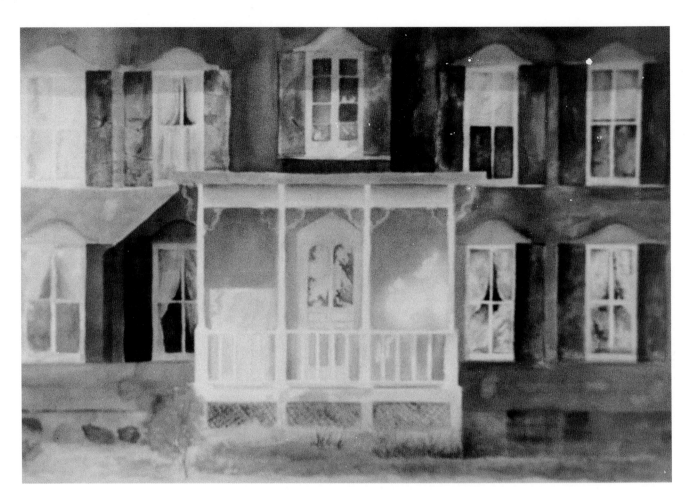

ELAINE M. CUSMANO
This Old House
22" x 30" (56 cm x 76 cm)
Arches 140 lb. hot press

To capture the worn, weathered quality of the house, I first painted the shutters a darker value than they would look when finished. When dry, I applied a wash over the wooden areas of the house and put the entire painting into a tub of warm water, scrubbing the surface with a toothbrush while it was submerged. I rinsed the paper under running water and when dry, repeated the entire process three more times. When finished, the paper's surface was slightly damaged and stained, producing the weathered and peeling-paint effect I desired.

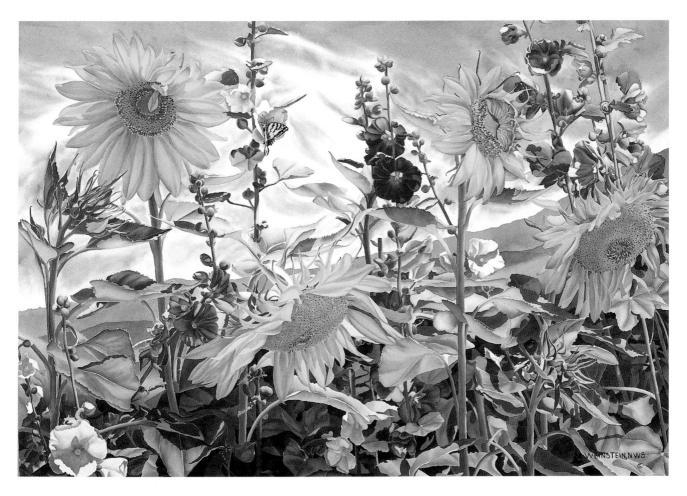

MARY WEINSTEIN
Sunsation
40" x 60" (102 cm x 152 cm)
Arches 300 lb. rough
Watercolor with acrylic

The primary goal of my work is the arrangement of shapes, along with the organization of space and movement into a harmonious composition. In *Sunsation*, the vertical thrust of the plants is supplemented by the diagonal design of the sky and mountain range. A balance of weight, space, warm and cool colors, softness and crispness, texture, variety of size of shapes, and contrasts of dark and light values were all taken into consideration in the composition.

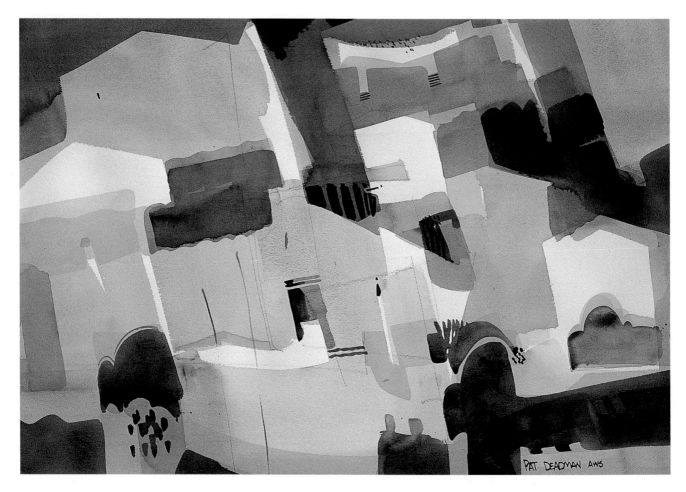

PAT DEADMAN
Manzanilla
22" x 30" (56 cm x 76 cm)
Arches 140 lb. cold press

Manzanilla is a city in Mexico with buildings of various materials, colors, and age all seemingly perched on the edge of a mountain. Overlapping shapes describe the position of the buildings, tilted shapes represent the mountainside and create interest and excitement, as well as departing from the absolute vertical and horizontal planes. Texture was created by blending wet color, waiting for a color to dry before applying a glaze, and marking with a small brush.

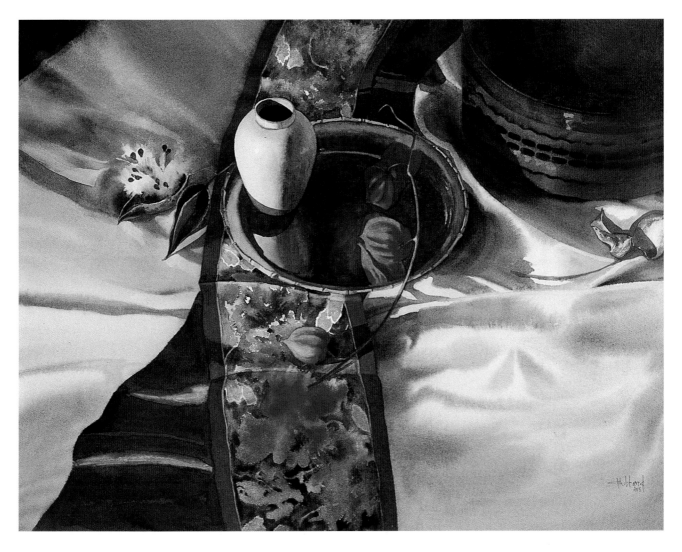

CAROL HUBBARD
Silk and Satin
28" x 36" (71 cm x 91 cm)
Arches 300 lb. cold press

For *Silk and Satin*, I designed a strong, directional force to offset the use of the soft, malleable fabric. Bisecting the brocade ribbon with the brass tray and its accessories slows down the viewer's descent in space, encouraging a perusal of the intersection where most of the action is taking place. Remarkable paintings originate from a workable formula while looking effortless, never trite, and seemingly new. A successful composition includes considerations of positive and negative space, repeated forms, line quality, motion within a limited space, and tasteful chording of color.

ZETTA JONES
Inside the Garden Fence
15" x 22" (38 cm x 56 cm)
Arches 140 lb. cold press
Watercolor with ink

Inside the Garden Fence is a contrast of delicate roses against the strength of iron and earth. Rose stems become the scrolls of a wrought iron fence and horizontal bands of earth add depth and stability to the movement of these scrolls. By motion and direction, iron and earth support the color and shape of the roses and unite to become one in a unique composition. Cold press paper was selected for its adaptability to a variety of textures.

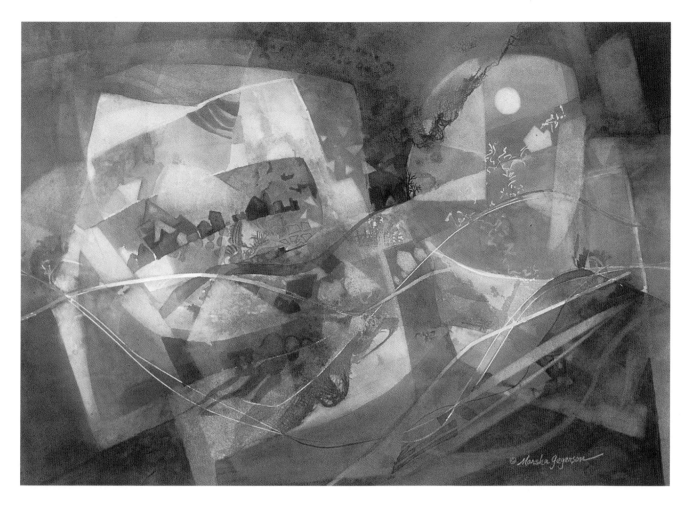

MARSHA GEGERSON
Harvest Moon
18" x 25" (46 cm x 64 cm)
Winsor and Newton 140 lb. cold press

Before putting brush to paper I ask myself a series of questions, the answers to which guide me through the painting process. Those questions include: How will I use the space? How will the viewer's eye travel through the painting? What will be the main shape? How will I break down the subject into simple, abstract shapes? What patterns are created? Are the shapes interesting? Do the value patterns create movement? And finally, does it have impact? It was this series of questions and answers that let me achieve the effect realized in *Harvest Moon*.

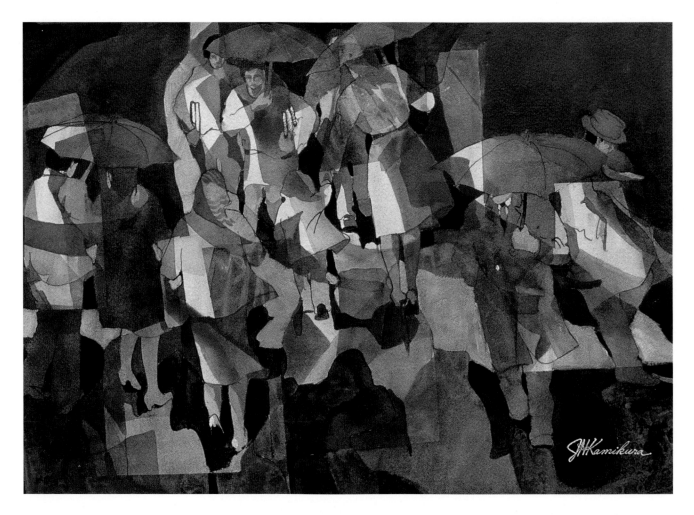

JOYCE H. KAMIKURA
Rain in Town
15" x 22" (38 cm x 56 cm)
Arches 140 lb. cold press
Watercolor with acrylic

With its refreshing, lively, and warm expressions, rain is life itself. Using vigorous and spirited shapes in an urban setting, I wanted to express rain with warm colors rather than the conventional cool ones seen elsewhere. An abstract underpainting in watercolor was done with large and medium shapes, paying special attention to design. Before introducing small shapes, I superimposed lively images of city life in the rain. The original abstraction ties the different shapes together, creating a sense of harmony throughout the painting.

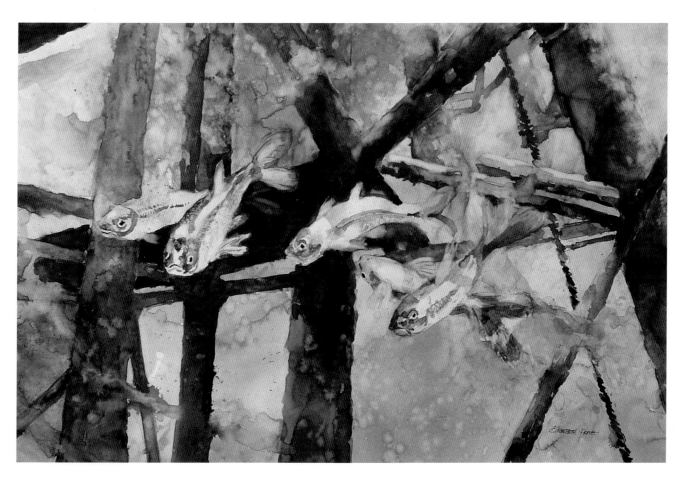

ELIZABETH HAYES PRATT
Under the Dock
19" x 29" (48 cm x 74 cm)
Strathmore 500 series hot press

Applying a large, loaded brush to dry rag bristol paper allows paint to stay on the surface, floating and creating blooms. Dipping my fingers in water, I flicked my wrist with force towards the damp area where I wanted bubbles and currents to form. I rolled a brayer over the orange color of the rusty post, moving and texturing the paint. I painted negatively from light to dark, freely and unevenly, to make the fish appear to be underwater. Movement created by loose, random brushwork was balanced by the compositional structure of the beams.

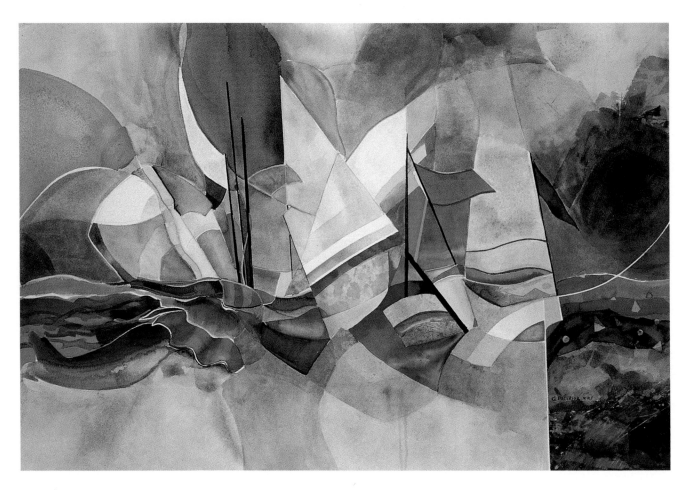

GLORIA PATERSON
The Saga of Peter Grimes
23" x 34.5" (58 cm x 88 cm)
Arches 260 lb. cold press

The subject was based on the myth of Peter Grimes, who was sentenced to eternally sail the oceans and never return to shore. This is represented by repeating boat shapes, with the varying dark and light colors implying differing weather conditions. The right-hand segment of the painting is cut off to suggest the forbidden shore. Unending, rolling seas are suggested by the horizontal composition and the curvilinear shapes.

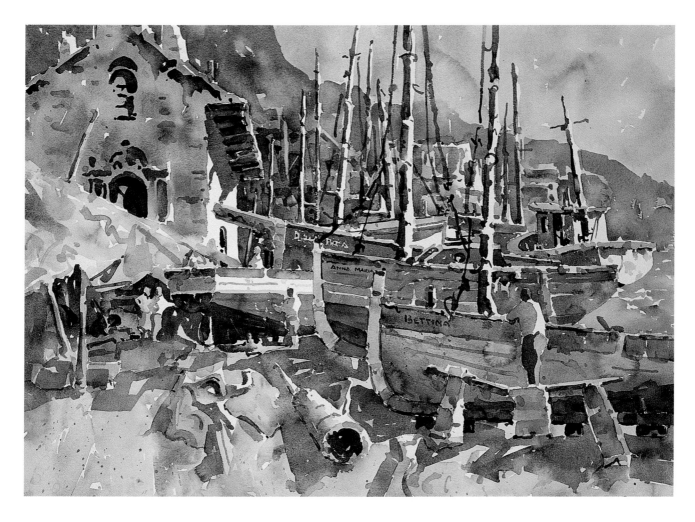

DAN BURT
Italian Boatscape
22" x 30" (56 cm x 76 cm)
Arches 300 lb. cold press

The subject afforded the opportunity to use combinations of curved and straight lines as well as different shapes. In painting a picture such as this one, I like to use unequal measures of line, value, color, texture, size, shape, and direction. Straight and curved lines tie a composition together while vertical lines give it stability. Values give variety, interest, and definition, and colors and color opposites excite the eye.

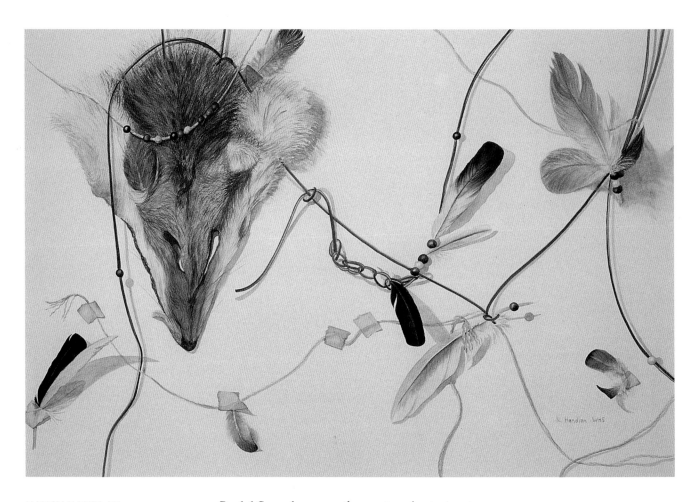

NANCY HANDLAN
Beaded Crown
19.5" x 29.5" (50 cm x 75 cm)
Strathmore hot press

Beaded Crown focuses on the coyote, using texture to emphasize fur and feathers. The crown of beads and feathers is a tribute to the animal. White and black beads signify life and death while green and blue ones represent earth and sky. The wet-in-wet underpainting was followed by drybrush for surface texture. Directional lines and division of space were achieved by painting strings and leather strips strung with wooden beads. The resulting still life is an interesting composition of ordinary objects assembled in a unique way.

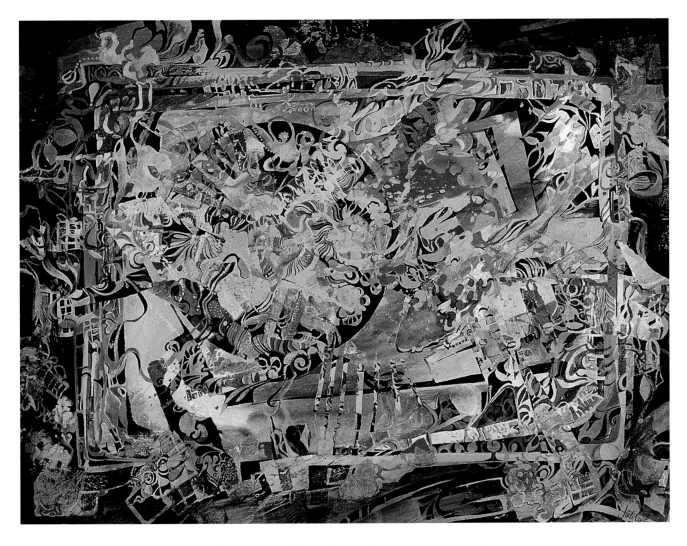

JUDI COFFEY
Silk Scarf Series: Cache
22" x 30" (56 cm x 76 cm)
Arches 140 lb. hot press
Watercolor with acrylic and gouache

Collage seemed the perfect medium for using color with flair to represent the unconventional. To create different textures, I used many hand-painted papers—Arches, rice paper, and Letra Max 1000. These collage pieces were my guide for the spontaneous designs that evolved. The border was as important as the center of the painting to the composition. I worked with watercolor and flat opaque gouache next to shiny acrylic. The dominant dark color of black and indigo helped to pull this abstract painting together while the fluorescent opaques enhanced the crisp, vibrant patterns.

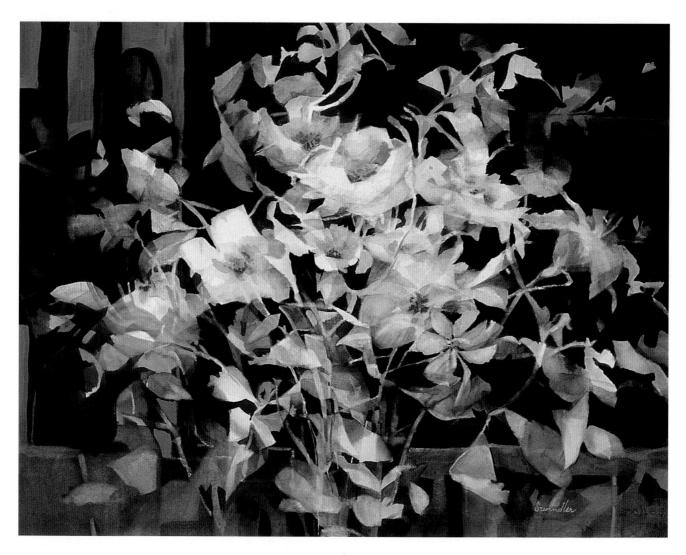

NANCY SWINDLER
Floral Variations No. 3
21" x 30" (53 cm x 76 cm)
Arches 140 lb. cold press
Watercolor with gouache

In *Floral Variations No. 3*, I started with a loose drawing, then applied cobalt blue on most of the page, leaving the exposed white of the paper to form various shapes. After tinting where the blooms would be, a mixture of indigo and black gouache delineated the shapes of the flowers. Using petal-shaped stencils that I cut, I refined the floral shapes by removing paint with water, a toothbrush, a sponge, tissues, and an electric eraser. This procedure produces a unique look because more of the details are achieved by removing paint than applying it. The result is a neutral painting with tints of color and intertwining lines that leads the viewer through the painting.

CAROLINE A. ENGLAND
Green Bay Orchid
21.25" x 14.25" (54 cm x 36 cm)
Arches 140 lb. hot press

While the focal point of this painting is in the center, the curves of the flower create a sense of energy and movement. A geometric sub-motif, strongly accented with the dynamic effect of a curve, enhances the vitality and motion. The shallow space has been divided into uneven segments, and thin transparent glazes of watercolor create subtle textures. The strength of *Green Bay Orchid* lies in the geometric forms that serve as a vehicle for showing the structure and patterns of nature.

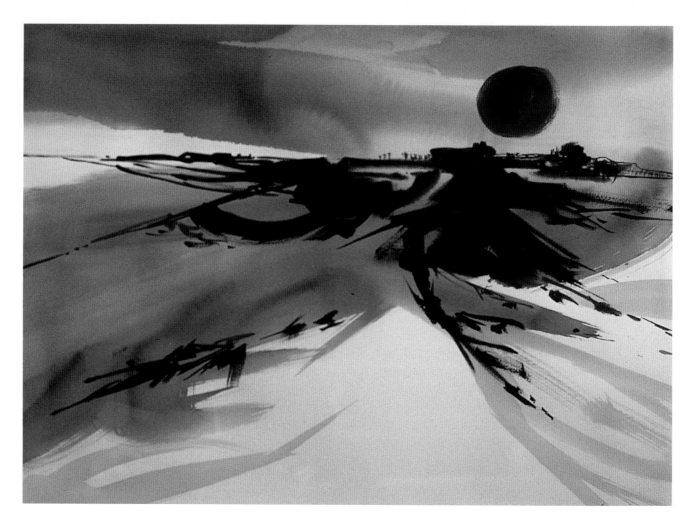

ROBERT E. CONLAN
Set in Ice
22" x 30" (56 cm x 76 cm)
Arches 140 lb.

For *Set in Ice*, my concern from the start was to present a realistic subject while balancing certain design elements. I allowed cool colors to dominate the picture and placed directional washes of paint so they would unify the painting and direct the viewer's attention to the center of interest. I established the line between the mountains and sky so it would divide the image into a $^2/_3$–$^1/_3$ proportion. The placement of the sun divides the sky into similar proportions.

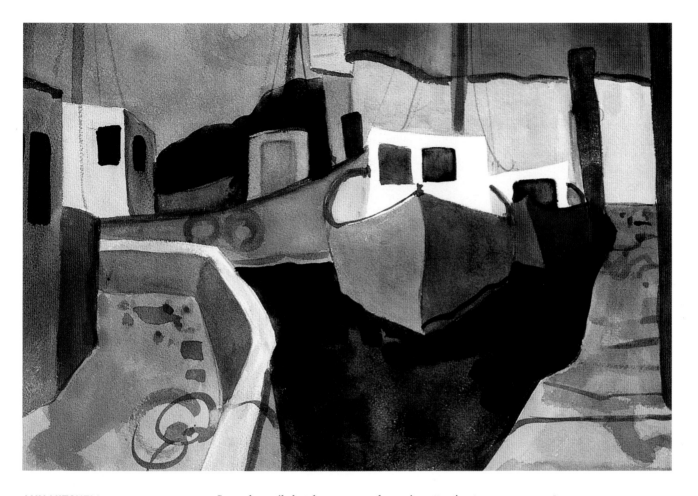

ANN MITCHELL
Boats
18" x 24" (46 cm x 61 cm)
Arches 140 lb. cold press

Several pencil sketches were made, paying attention to shapes and their relation to each other. I divided the space into large shapes and decided where to place the lights and darks. The opening at the bottom leads the viewer up into the painting. After the design was worked out, the painting was done quickly and intuitively with a few calligraphic markings added for interest.

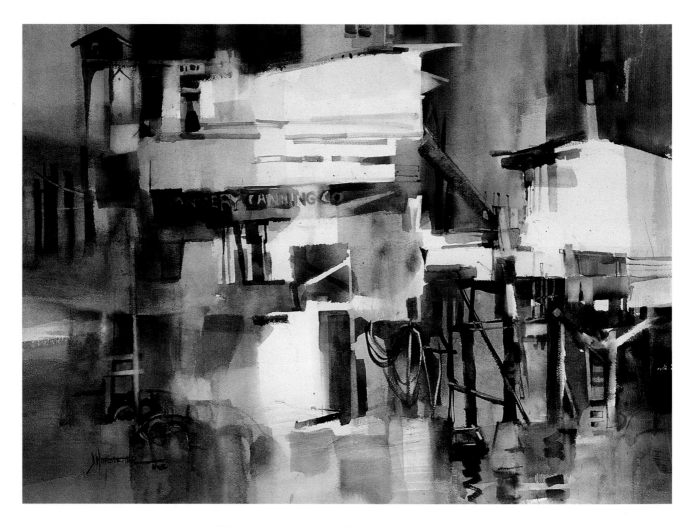

JANE R. HOFSTETTER
Wharfwood
21" x 29" (53 cm x 74 cm)
Arches 140 lb. cold press

Old Cannery Row is a wealth of textures and broken shapes that were waiting to be painted. Nature creates beauty with old patinas enhanced by weather and water. *Wharfwood* is a study of contrasts—warms against cools and the plain white of the paper against a multitude of patterns. I planned my focal point to have the greatest contrast and most interesting detail, searching for a statement of texture. I scraped out paint in wet areas, and when the color was dry, lifted off places with stencils and added further details.

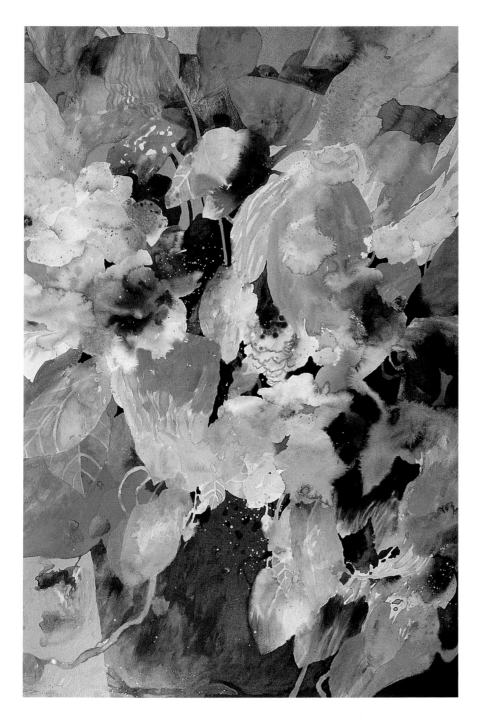

DOROTHY GANEK
Terra-cotta
41" x 29" (104 cm x 74 cm)
Rives BFK acid-free 100% rag
Watercolor with acrylic

Terra-cotta began with spontaneous wet-in-wet applications of watercolor, with abstract patterns being established by the bleeding colors. As the paint dried, I emphasized the contrasts between cool and warm colors, hard and soft edges, dark and light values, large and small shapes, as well as thin and thick lines while I developed the images of leaves, petals, and flower pots. I repeated the leaf pattern to avoid chaos and maintain harmony in the design. Magnifying the flower pot allowed me to zoom into the subject and dramatize the texture and patterns.

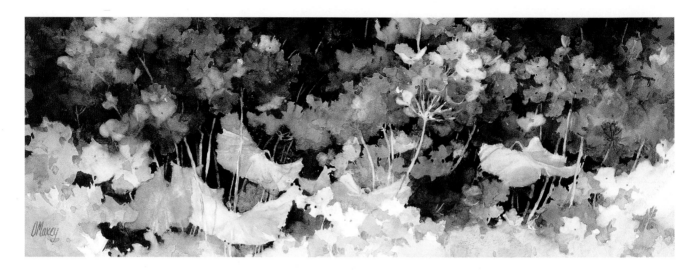

DIANE MAXEY
Riotous Living
11" x 30" (28 cm x 76 cm)
Lanaquarelle 140 lb. cold press

After composing a small light-dark plan, I used scraps of watercolor paper to develop the color pattern. Design problems caused by the unusual format had to be resolved before painting. While painting, my full attention was on pigment, wetness of paint and paper, and edge quality. Using medium values of pure pigment wet-in-wet, I created the soft powder-puff look of the primrose blooms. Reds and violets woven together with soft edges and low contrast forged unity. Crisp, glazed, green leaves contrast with the blooms and generate a passage of light that moves the viewer through the painting.

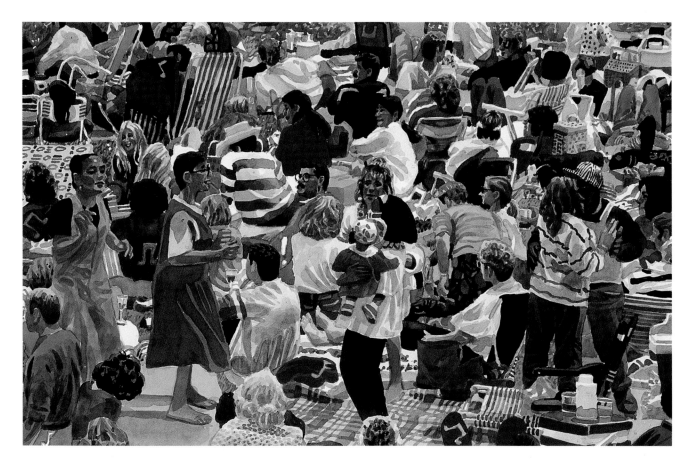

JOE JAQUA
The Grove Is Jumpin'
22" x 35" (56 cm x 89 cm)
140 lb. cold press

A free jazz concert at Stern Grove in San Francisco had the crowd dancing and talking with one another. I liked the mix of people and tried to capture the movement and feeling of the event, as well as the patterns of clothes, blankets, and baskets. A loose technique was appropriate to catch the event's spontaneity.

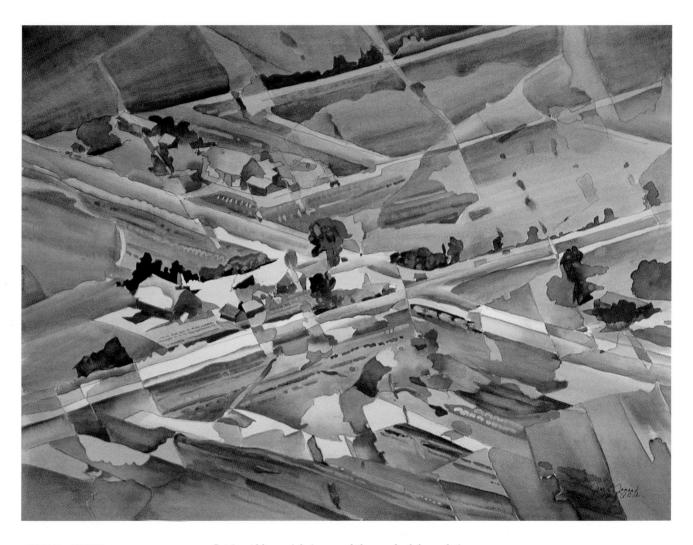

JANE E. JONES
Green Pastures
22" x 30" (56 cm x 76 cm)
Lanaquarelle 140 lb. cold press

Intrigued by aerial views and the gradual degradation of focus from the foreground to the distance, I utilized fluid washes to establish tone and ambiguous forms to create depth. Using both transparent and opaque watercolor gives the painting a balance. Transparent colors are used to give the sensation of seeing through clouds and the land forms are painted more opaquely to give solidity. The sunlit areas are moving forward in space, and the darker, grayed-down areas move back to give depth to the painting.

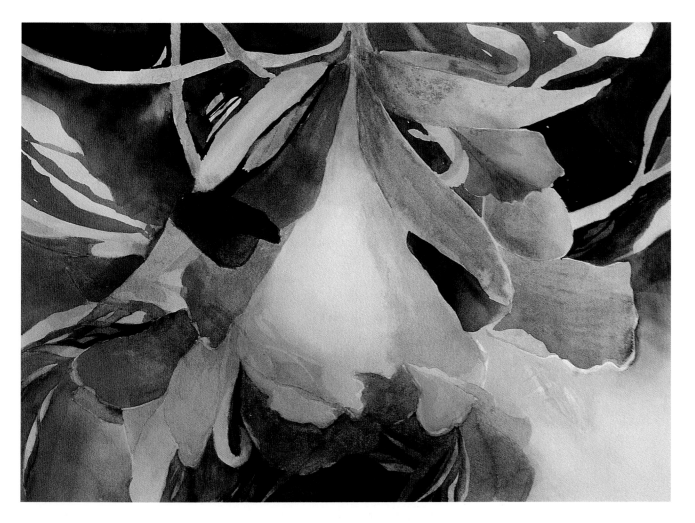

CARMEN NEWMAN BAMMERT
Last Light
15" x 21.25" (38 cm x 54 cm)
Winsor and Newton 260 lb. cold press

Similar to a firm foundation in architecture, proper composition and design serve as the foundation blocks of a good painting. Working in an intuitive style, with no pre-conceived subject, *Last Light* was done in a pyramidal style when viewed horizontally, but functions equally well when positioned vertically.

MARILYN GROSS
Symbols, #5
24" x 18" (61 cm x 46 cm)
Fabriano 100% rag hot press
Watercolor with ink and Caran
d'Ache crayons

Symbols, #5 is based on symbols
related to the letter *R*. This painting
reflects a rich interplay of move-
ment between foreground and
background, allowing the eye to
move freely about the painting.
Repetitive textures throughout the
work unite the composition, and
tipping planes within the painting
direct eye movement.

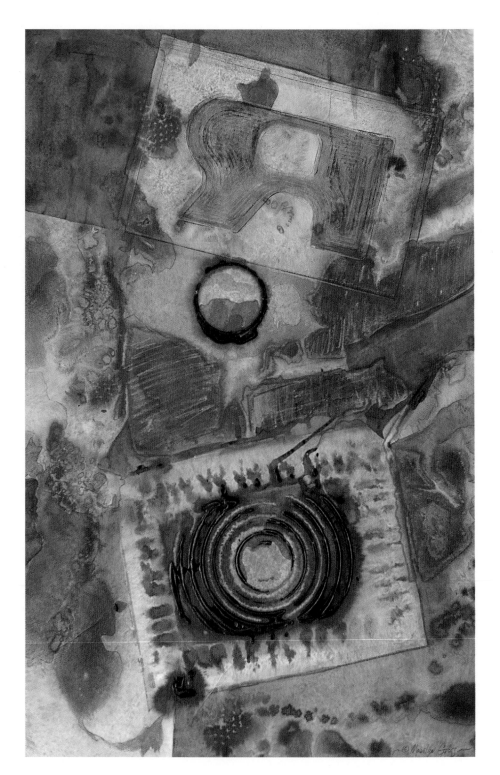

PHILIP GURLIK, JR.
Los Alamos
18" x 26" (46 cm x 66 cm)
Arches 140 lb.
Watercolor with acrylic and acrylic
medium

Unusual texturing was achieved by laying down a pattern of transparent acrylic medium that reacted to washes of acrylic paint differently than the paper's unpainted surface. The foreground lines and patterns establish depth and color within the painting. Variation of texture adds a feeling of movement, and depth was achieved with a few harder-edged images juxtaposed against a softer background. The flash in the background of *Los Alamos* is a metaphor for the beginning of the atomic age.

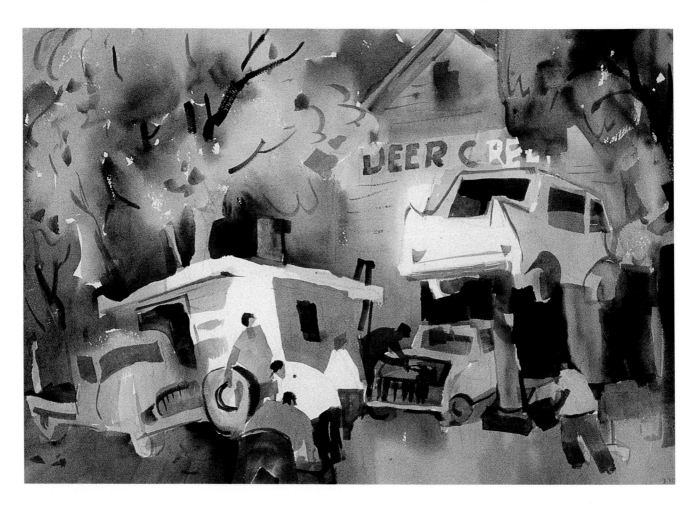

EDWIN C. SHUTTLEWORTH
Deer Creek Auto
14.5" x 21.5" (37 cm x 55 cm)
Arches 140 lb. cold press

Deer Creek Auto was done on damp paper, wet-in-wet, with accents and calligraphy added when dry. I enjoy the freedom of inventing light sources in my work, all in the service of the light-dark pattern. Intense light shapes are contrasted against my darkest darks and highest chroma colors. Most of my paintings are done from memory, minimizing the tyranny of the model.

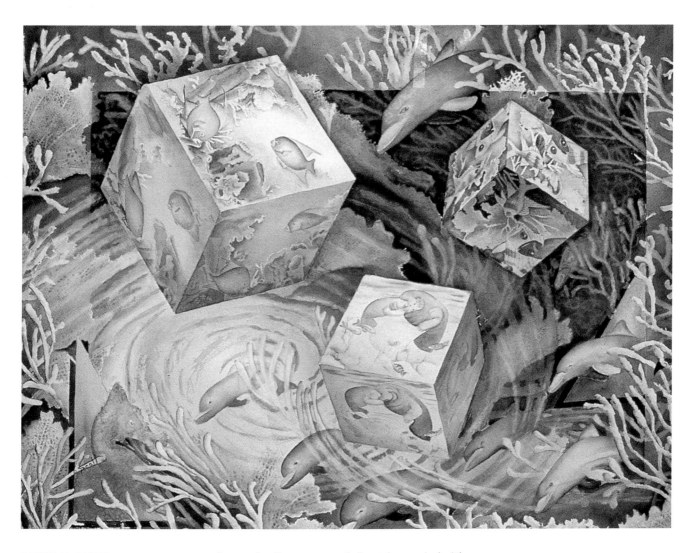

PATRICIA SCOTT
Maelstrom
22" x 30" (56 cm x 76 cm)
Arches 140 lb. cold press

As a scuba diver concerned about the survival of the oceans' reefs, I wanted to depict a whirlpool sucking blocks of aquatic life into extinction. Using the computer program Adobe Photoshop to edit several previous paintings, I merged them into one image, creating texture and arranging the elements into a satisfying composition. Using a gray-scale printout as a value sketch, I drew the composition onto watercolor paper. Traditional techniques of floating pigments onto wet paper and both positive and negative brushwork were used to create the swirling texture and to convey the feeling of turmoil.

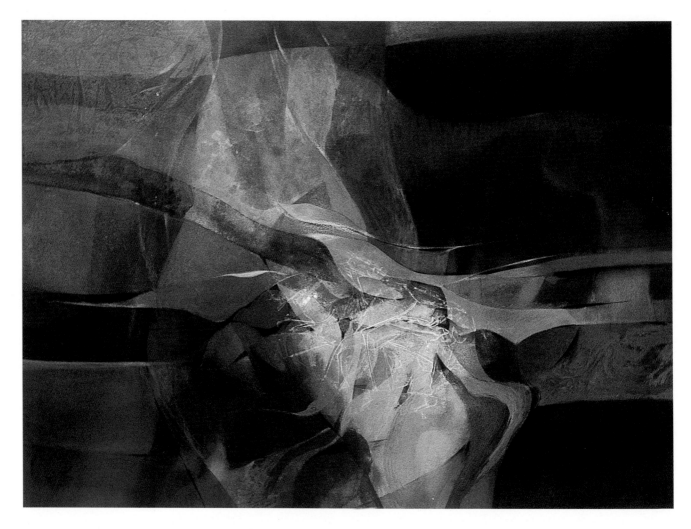

ROBERT HALLETT
Shreds of Time
22" x 30" (56 cm x 76 cm)
Arches 140 lb. cold press
Watercolor with acrylic

Composition is a creative interpretation of the subject rather than a reflection of it. Movement and space are created by static or dynamic gestures, the vertical/horizontal being passive and the diagonal/curvilinear being active. Both two- and three-dimensional space is suggested by texturing and layering shapes and volumes. My subjects are usually discovered after making a design from a random underpainting. In addition to the usual watermedia materials, I use sponges, rollers, wax paper, cellophane, and cardboard. My techniques include washes, glazing, stipple, spatter, and direct brushing.

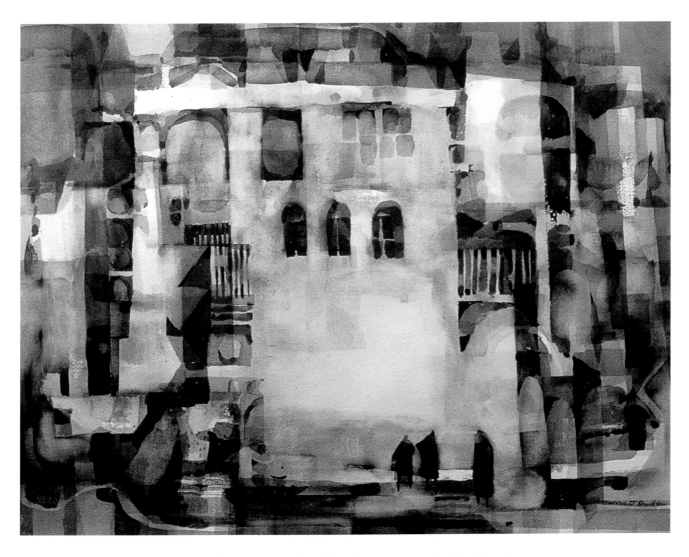

MORRIS J. SHUBIN
The Arches
22" x 30" (56 cm x 76 cm)
Arches 300 lb. rough

Areas on a wet sheet of rough paper were saturated with cool colors and a few warm ones. When dry, certain areas were carefully and partially sponged out. Repeating this application of opposite colors several times impregnated the sheet and allowed luminous, rich, stained colors to emanate. Windows and arched curves were repeated and accented, and representations of people were included for scale.

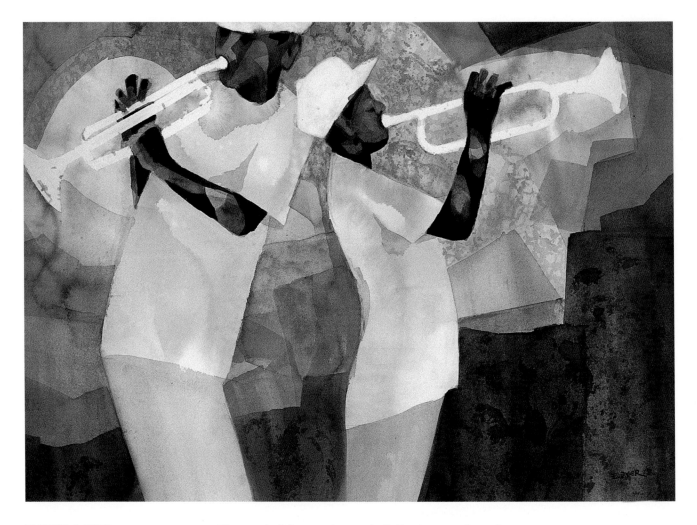

EVALYN J. DYER
Brass Duet
22" x 30" (56 cm x 76 cm)
Whatman 200 lb. cold press

Placement of shapes acts as an invitation to weave through the design elements of a painting. In *Brass Duet*, the whites, the darker angular arms and faces, and the vertical counter-body movement all create a force that leads to the focal point of the musicians' heads. The dark-gray glazing on the bottom holds the viewer in the painting. Throwing water on the damp initial wash, identifying with strokes of the same color around the heads, and dappling a cork in paint and pressing it into the lower dark areas added texture to the painting.

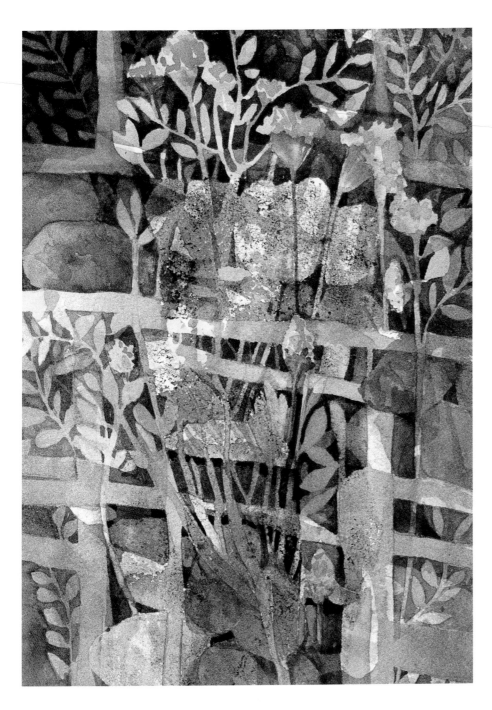

HELEN GWINN
Wild Marigolds
15" x 10" (38 cm x 25 cm)
Arches 140 lb.
Watercolor with charcoal powder

Before painting, I sprinkled charcoal powder randomly over the paper and poured water over it, scattering and spattering the charcoal. When it dried, I sprayed several layers of workable fixative over all, then began to paint with watercolors. Trusting my intuition, I painted varied colors and shapes onto the charcoal-textured surface and slowly began to emphasize the positive organic shapes I saw by darkening the negative spaces. Eventually the fence shape developed, providing a link and enabling the various parts to come together in a meaningful whole.

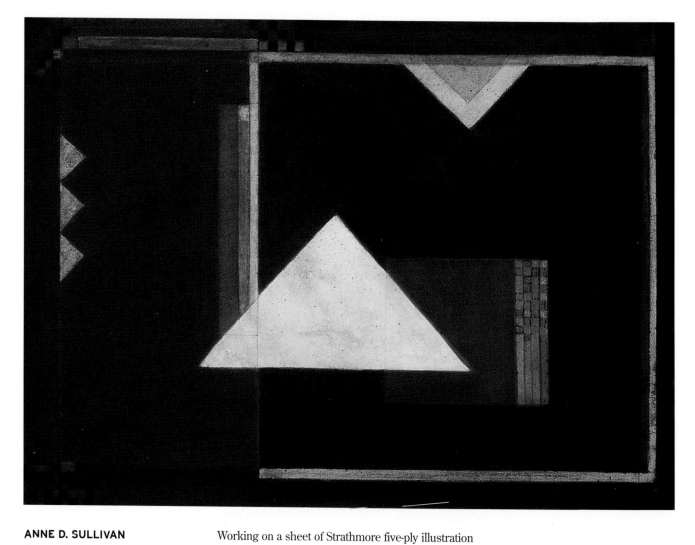

ANNE D. SULLIVAN
Connections—PAX II
20" x 30" (51 cm x 76 cm)
Strathmore five-ply illustration board
Watercolor with acrylic ink and
Prismacolor pencil

Working on a sheet of Strathmore five-ply illustration board, I applied washes of watercolor in random patterns to establish a base for the painting. I then used acrylic inks to achieve balance, contrast, variety, and movement in the composition. I tried not to become so concerned about formal design principles that I would preclude fresh discoveries or limit my ability to discover new visions of aesthetic merit. *Connections—PAX II* is part of a series derived from my interest in texture as observed in the architecture of Europe and the Mediterranean countries.

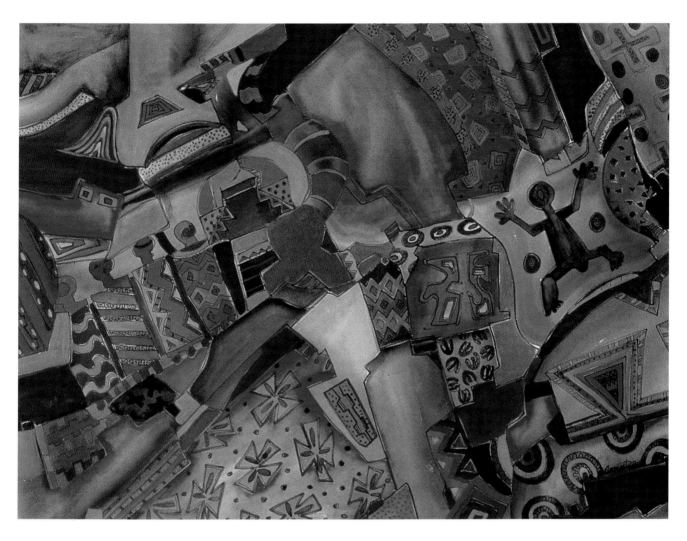

CHARLOTTE CORNETT
Wall Art
22" x 30" (56 cm x 76 cm)
Lanaquarelle 140 lb.
Watercolor with acrylic pen

Working without an initial sketch, *Wall Art* began first with a wash of brilliant color that created an energy and excitement to build on as the work progressed. After this was dry, I started developing the shape of the painting using lost and found edges, line, and value. Working from all sides of the paper, I developed the basic design by adding shapes and experimenting with the overall design until I was satisfied.

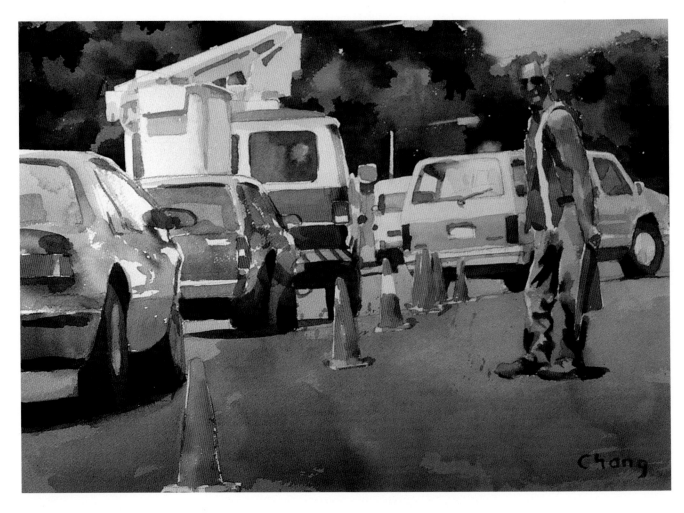

HWANG NAM CHANG
Flagman
14" x 20" (36 cm x 51 cm)
Arches 150 lb.

I tried to control the compositional elements of this picture to make the flagman the center of interest, rather than the traffic surrounding him. I achieved this by placing a few spots of red near the flagman and a contrasting blue-green wash elsewhere in the picture. I also used the white of the paper to attract the viewer's eye toward the center of interest. Finding a painting's focal point is similar to peeling back the layers of an onion—when you come to the center, you may not find a distinct center, but rather a combination of interesting shapes and colors.

MANETTE FAIRMONT
Valley of the Moon
15" x 15" (38 cm x 38 cm)
Arches 140 lb. cold press rag

My most recent suite of paintings has been concerned with the juxtaposition of rich, organic patterns with clean, flat geometric shapes; and using gray values with luminous lights. Furthermore, I am interested in establishing a sense of movement by emphasizing various speeds of circular shapes. One of the ways I accomplish this is by placing muddy colors next to clear washes; another is by laying transparent staining colors over dark, sedimentary, opaque colors. I have chosen to work with transparent watercolor because of its unpredictability and directness of expression.

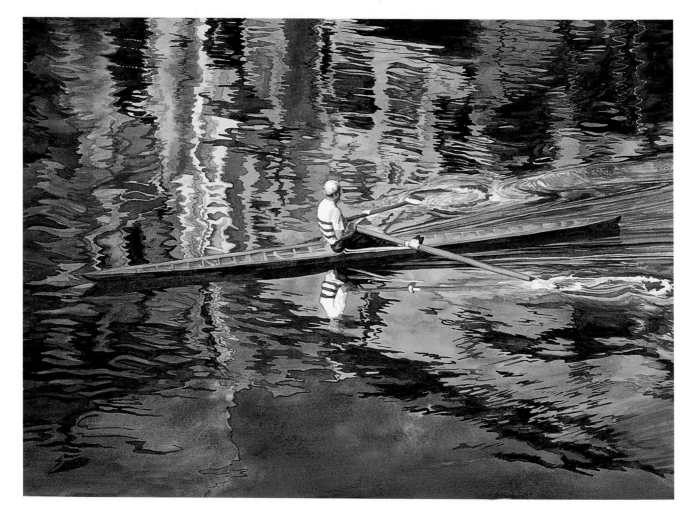

LAUREL COVINGTON-VOGL
Ponte Vecchio Reflections
18" x 25" (46 cm x 64 cm)
Winsor and Newton 100% rag
140 lb. cold press

While in Florence, Italy taking photographs for future reference, a scull appeared on the Arno River and the resulting photo contained the unique composition I wanted. The reflection of the Ponte Vecchio Bridge created a series of diagonal lines and the scull cut across these lines as it moved in the opposite direction. The resulting X shape was emphasized by intensifying the colors of the bridge's reflection and by using a bit of red on the boatman to create a complementary color harmony. The rippling lines and color contrasts always return the viewer to the scull at the center.

ANNA CHEN
Rolling Glass Balls
25" x 40" (64 cm x 102 cm)
Arches 140 lb. hot press

I was inspired to paint *Rolling Glass Balls* by doing just that—rolling glass balls of various sizes on a table and watching the intricate curved lines and geometric color patterns take shape as the spheres caught the sunlight. A close-up view enhanced the details and a tiny robot was placed in the middle to make the composition more interesting and complete. Warm reds were applied over all to create a feeling of movement. *Rolling Glass Balls* was not complete until it was evaluated for its value and harmony in colors and the effects of lines forming the composition.

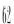

JOYCE WILLIAMS
Scintillating Stockyards
22" x 30" (56 cm x 76 cm)
Arches 300 lb. cold press

The subject's linear quality, a Texas stockyard at night after a rainstorm, gave me the opportunity to build a good composition with well-placed lines and color. Using a limited palette of red, blue, and yellow, I painted a very dark sky as background to show a night scene, as well as to make the predominantly white subject stand out. Composition of the piece was extremely important to guide the viewer's eye through the painting.

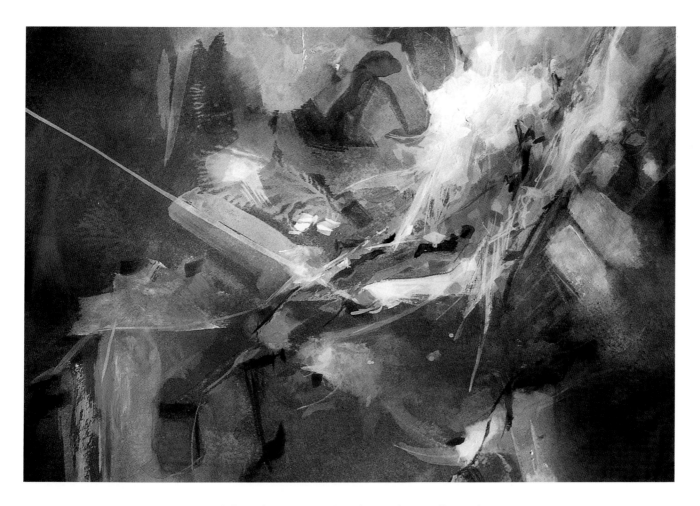

J. LURAY SCHAFFNER
Blue Sky at Night
30" x 40" (76 cm x 102 cm)
4-ply museum board
Watercolor with ink and pencil

Color, value, texture, points, line, and area radiate various amounts of energy within my work and are all components of the composition. Working on a two-dimensional surface to create the effect or illusion of depth and motion, the surface becomes a spatial world of objects circulating between specified boundaries, thus creating an aesthetic image.

HENRY BELL
Morning Conversation
38" x 32" (97 cm x 81 cm)
Arches 260 lb. hot press
Watercolor with acrylic and gouache

Objects within *Morning Conversation* create strong diagonal lines that lead the viewer to the center of interest, the American flag. Transparent watercolor was the obvious choice for the window curtains and the flag. Opaque watercolor and acrylic worked best for the pastels of the cushions and the rich darks of the wall and floor. With hot press paper, I was able to do textural brushwork on the walls and floor without getting a worked look that might occur with cold press paper. The texture of the wicker and the light coming through the soft curtains create a pleasant contrast to the solid, flat areas.

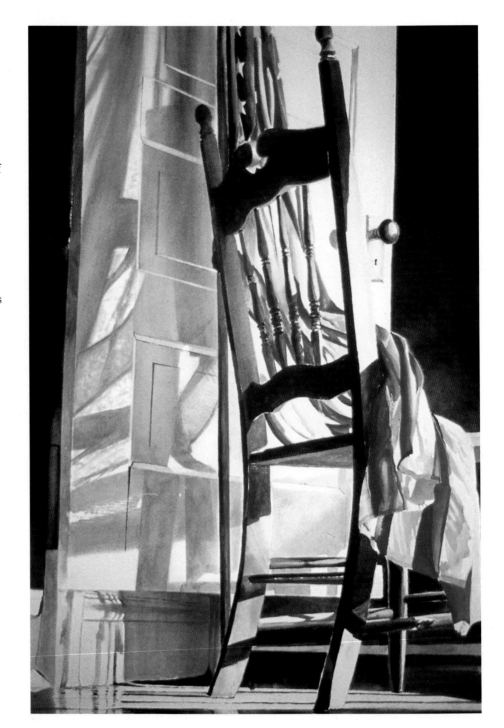

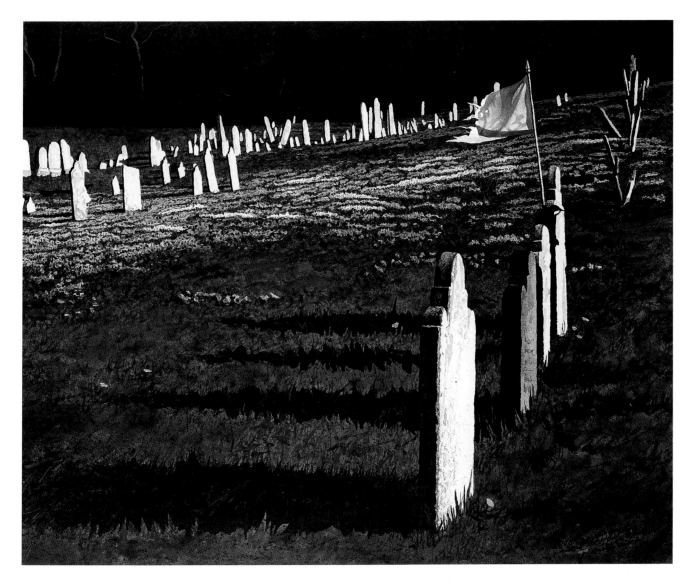

DOUGLAS WILTRAUT
Heaven on Earth
21" x 29" (53 cm x 74 cm)
Arches 300 lb. rough

I used an instinctive composition to present the white headstones standing amidst the carpet of mountain pinks, with the flag expressing the passage of time. Whenever I present a subject like this that is being affected by the wind, I give more space to the area into which the wind is blowing so there is a natural sense of motion. Right-to-left movement is reinforced by the direction of the shadows cast by the headstones. The perspective of the row of headstones leads the viewer's eye back to the important focal point of the flag.

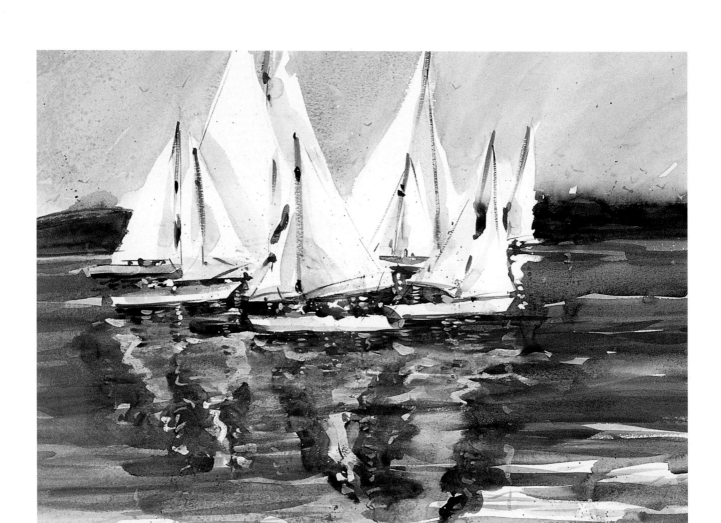

RALPH BUSH
Sunday Races
20" x 25" (51 cm x 64 cm)
Strathmore No. 500 140 lb. cold press
Watercolor and gouache

Sunday sailboat races are common in Rockport, Massachusetts. At one such race, I made a number of quick, thumbnail sketches of sailboats clustered together waiting for the starting gun to be fired. I then chose the sketch with the strongest composition to paint. All the movement and wind on the sails positioned at the top left was balanced by the reflections over the water and waves.

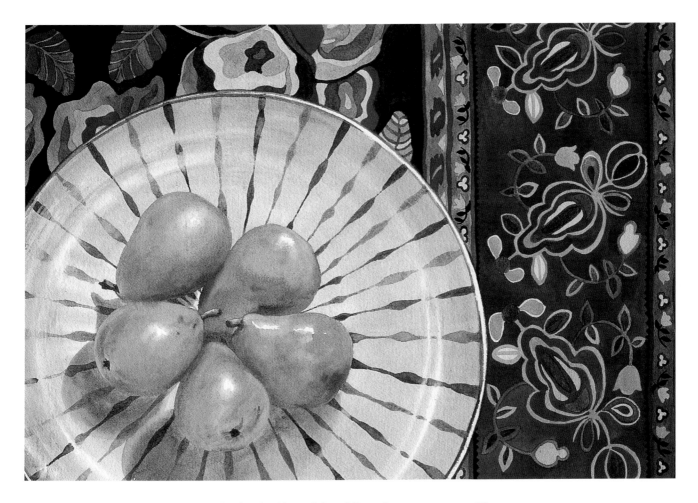

ANNE HAYES
Pears Oriental
15" x 22" (38 cm x 56 cm)
Arches 300 lb. cold press

In planning *Pears Oriental,* I sought a strong composition with the oriental cloth and plate, so I chose green pears to complement the red of the cloth and to repeat the shapes in the border. The stripes in the plate burst outward to create movement. I painted the pears first, while they were still fresh, then added a light wash on the plate, carefully leaving a white highlight. After glazing the background with raw sienna and allowing it to dry, the design was sketched in. The dark colors in the cloth enhance both the plate and pears.

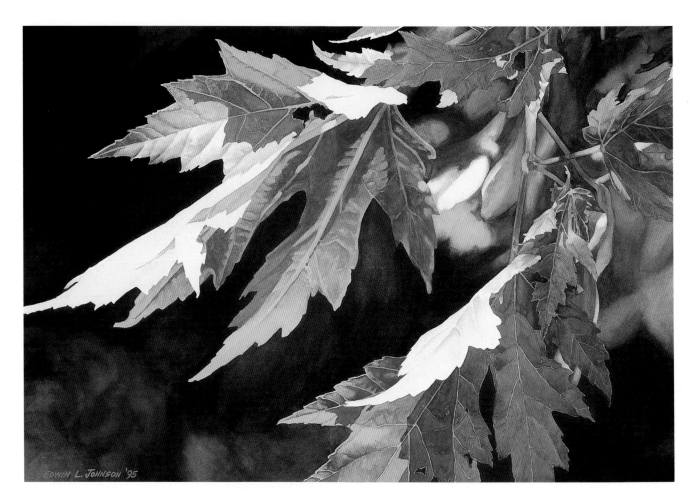

EDWIN L. JOHNSON
Sunlit Maple
19.5" x 29" (50 cm x 74 cm)
Strathmore 100% rag

Relying heavily on photography for the images I paint, I shoot in black and white, as well as color, and spend hours sorting through the accumulated material, studying them for content. In *Sunlit Maple*, I focused on a small section of a subject, concentrating on abstract qualities, rhythm, and movement. Patterns of light and dark, complexity of form, dramatic or unusual lighting, and surface pattern are used to make a realistic painting with an abstract structure.

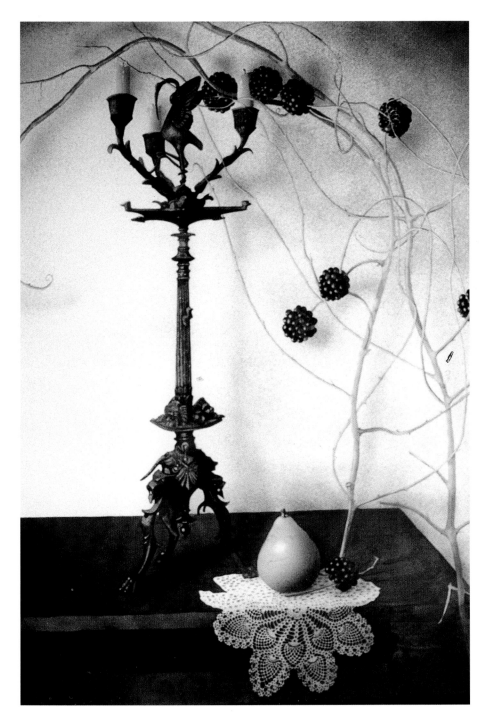

K. DAWSON
Candelabra with Pear
30" x 22" (76 cm x 56 cm)
Lanaquarelle 300 lb. cold press

I borrowed an antique candelabra to serve as the focal point of *Candelabra with Pear*, not wanting its beauty and intricacy to get lost in a complicated composition. The left-of-center placement was balanced by the vivid color of the pear and the delicacy of the lace. Blank space was broken up with brambles that bring the viewer's eye toward the focal point. I airbrushed the pear and parts of the candelabra, then lifted off paint for highlights. Background texture was achieved using the spatter nozzle of an airbrush. Bronze watercolor used sparingly highlighted the candelabra, giving it a subtle sheen.

BRAD DIDDAMS
Ain't No Petunias
33" x 22" (84 cm x 56 cm)
Arches 555 lb. cold press
Watercolor with gouache

My compositions are intended to direct the viewer's eyes around the painting. In *Ain't No Petunias*, I wanted the viewer to enter the picture at the lower left and then travel to the ginger jar, which arches over the point of highest contrast and detail. That brings the viewer to the protea, near the center of the picture, from where the viewers would continue to the artichoke, the plum, and back to the yellow kumquats at the lower left. I settled on this particular composition after taking forty or fifty photographs of the setup, choosing the best arrangement of objects, and painting from that photograph.

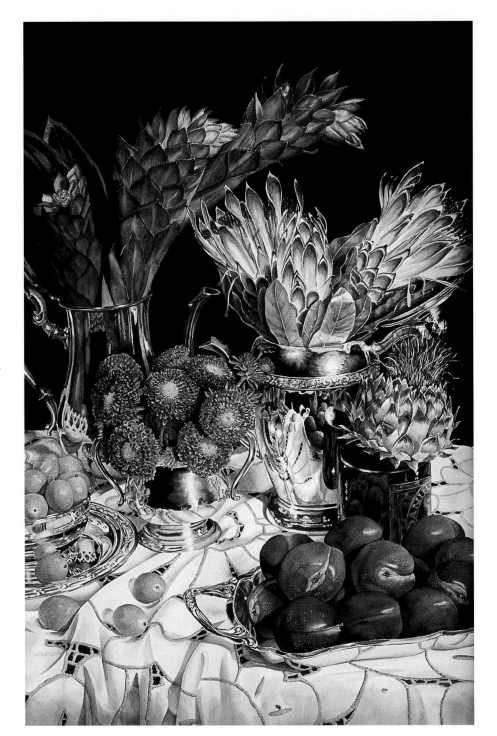

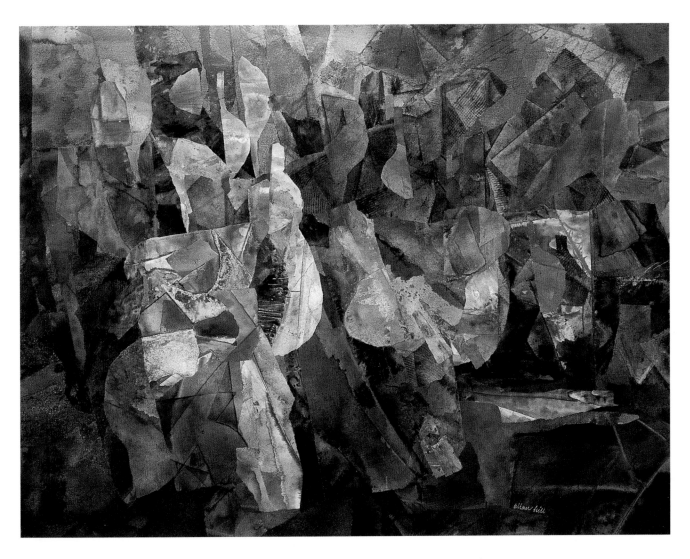

ALLAN HILL
Specific Gravities
22.5" x 30" (57 cm x 76 cm)
Arches 140 lb. hot press
Watercolor with acrylic

Collaging prepared materials gave me a notion as to where the painting would start. I arrived at the composition after arranging and rearranging the materials. Imagery derived from nature, which implied rather than illustrated natural forms, was the direction I took. Fluid qualities of watermedia on smoother papers suit my spontaneous approach. Pigments were poured and spread with little brushwork, and pieces of paper, cloth, glass, etc. were added to achieve texture and interesting edges. *Specific Gravities* developed an energy that implied falling, which I emphasized in the final composition.

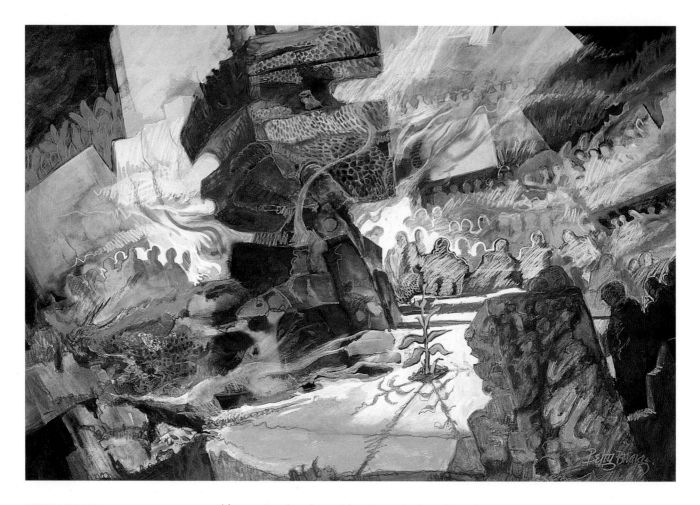

BETTY BRAIG
The Forum
30" x 40" (76 cm x 102 cm)
Strathmore cold press
Watercolor with acrylic and
watercolor crayon

After waxing the edges of the watercolor board taped to a drawing board, I tilted the board over a sink and poured a clear water design over the surface. Aged acrylic paint in water was poured into the design, and when the desired visual effect was achieved, the board was laid flat to stop the float process. While wet, wipe-outs, stamping, and spattering of color and water were done to enhance texture and movement. After drying, the overall design was blocked out and direct watercolor painting identified the visual imagery, glazing was done to add depth to the darker values. Crayons added excitement with contour and gesture lines.

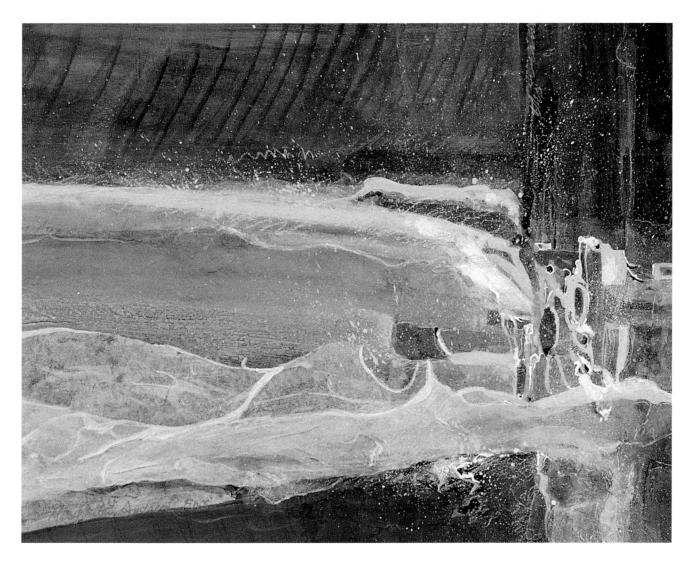

MARY ELLEN ANDREN
Soft Flow
13" x 16.5" (33 cm x 42 cm)
Crescent 114 cold press
Watercolor with acrylic

Much of my work relies on the layering and flowing of color; building layers of color yet keeping the transparency as long as possible. Looking at shapes and their relation to edges, I build texture as the work proceeds, working toward balance and harmony. Calligraphy is used between the layers, allowing the painting to suggest subject matter while maintaining an abstract quality.

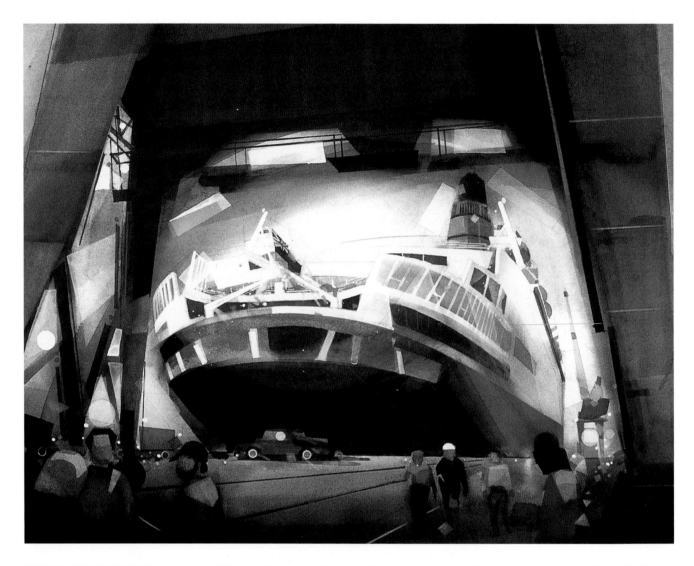

DONALD STOLTENBERG
QE2 in Dry Dock—Boston
21" x 29" (53 cm x 74 cm)
Arches 140 lb. cold press
Watercolor with Chinese white

The most important elements of a strong design are simple shapes that organize all the elements of the picture. In *QE2 in Dry Dock—Boston*, a series of oval shapes defines the various structures and projects them into the pictorial space. The ship is a large dark oval sitting inside the strong, dark, curving lines of the traveling crane. The figures, tracks, and vehicles mimic the lines of these dominant oval shapes. A tension is established by using sharp focus and contrast to bring distantly drawn, receding forms to the surface of the picture.

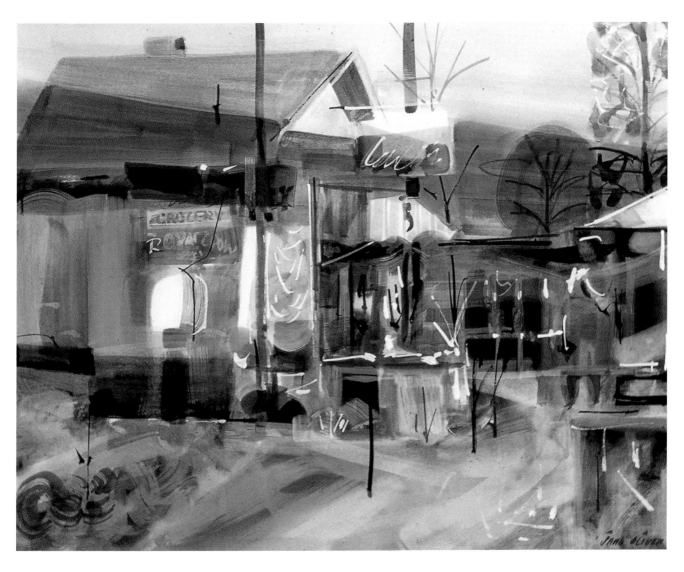

JANE OLIVER
Woman at the Store
16" x 20" (41 cm x 51 cm)
140 lb. hot press

The staccato effects of the thin black and white lines give
a sense of movement to *Woman at the Store*. Broken per-
spectives and deliberately distorted roof lines avoid a static
look and help enliven the composition. I soaked the hot
press paper, laid it on a board, and applied the ground,
sky, and large masses. After taping the paper down and
letting it dry, I added details and line effects, finishing
with glazing.

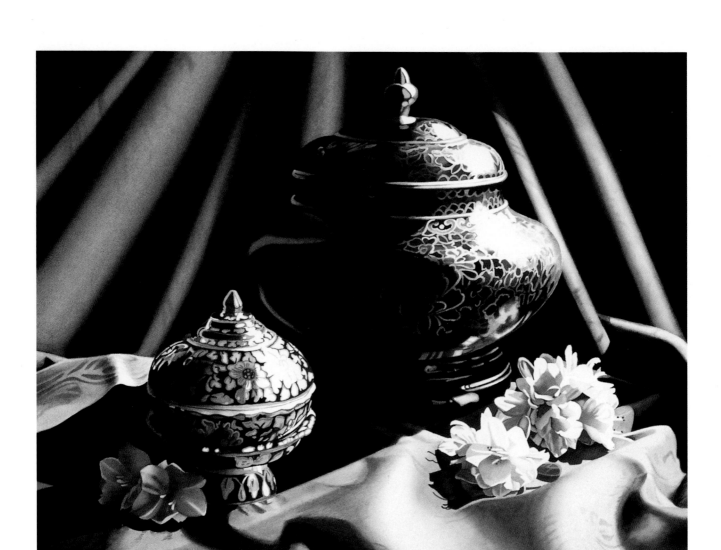

BARBARA K. BÚER
Cloisonné Still Life
22" x 30" (56 cm x 76 cm)
Arches 140 lb. cold press
Watercolor with acrylic

So the cloisonné surface would appear sharp and hard-edged, I chose to use the softness of the drapery folds and the velvety texture of the azaleas as counter-points. The diagonal lines of the background drapery and the circular motion of the foreground drapery keep returning the viewer's eyes to the focal point. Strategically placing the azalea blossoms in shadow on the left and bathing them in sunshine on the right heightens the interest. The cloisonné objects were painted directly onto a dry surface while the soft folds of the drapery were achieved by painting wet-in-wet.

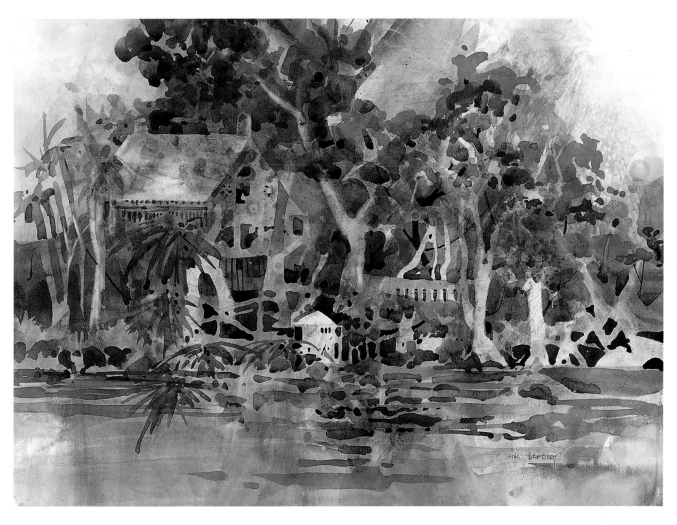

HAL LAMBERT
Island Red
22" x 30" (56 cm x 76 cm)
Bockingford 140 lb. cold press

I began painting loose washes with no particular subject in mind and after several washes were applied, a theme developed. Natural forms, structures, and space were created, and the elements of the composition were designed as large masses made up of smaller shapes. A limited palette of transparent colors helped unify the painting. Negative painting produced a shimmering effect, similar to that of moving light. By keeping the painting spontaneous, I tried to let the viewer complete the visual description of the total image.

SHIRLEY STERLING
View from Above
30" x 22" (76 cm x 56 cm)
Lanaquarelle 140 lb. cold press
Watercolor with acrylic

To provide an interesting variation on traditional subject matter, I used either free-form or geometric divisions of pictorial space and an unusual perspective. In *View from Above*, I used the free-form division to project a rhythmic, flowing quality to characterize the organic forms of the water lilies. Contrasts of light and dark, warm and cool, and large and small provide excitement while texture becomes a force in directing and holding the viewer's eye within the format. Texture describes the feel or surface quality of a subject; using acrylics in the manner of watercolor makes many exciting textures possible.

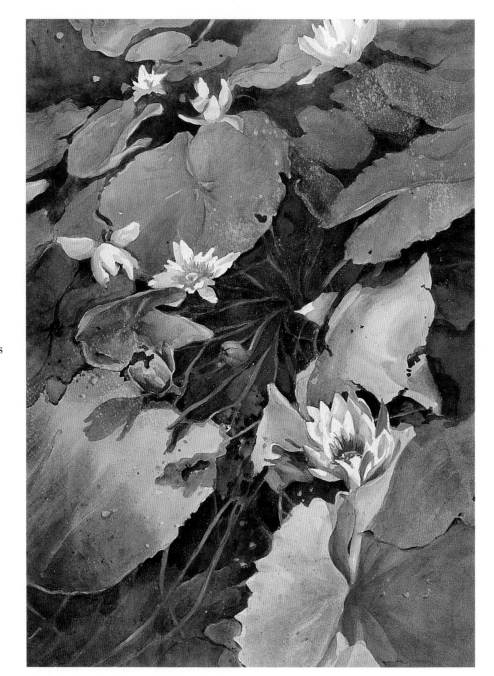

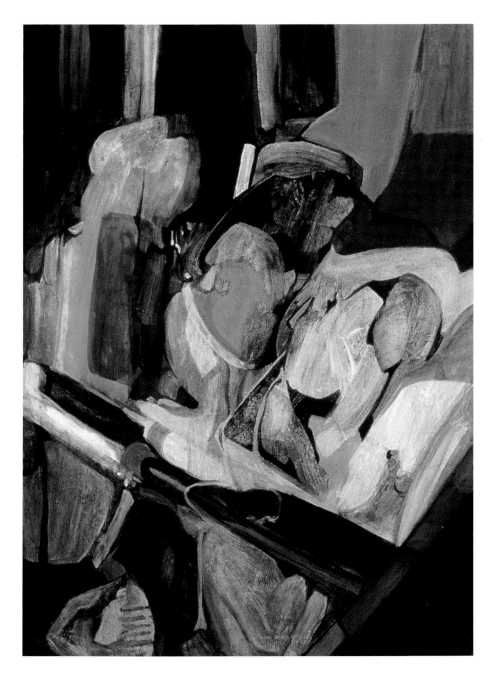

PATSY SMITH
Fruit Cart
30" x 22" (76 cm x 56 cm)
Aquarius
Watercolor with acrylic

I painted and printed interesting
fruit-colored shapes all over the
surface, creating a diagonal as
well as other geometric shapes to
add excitement and contrast to the
rounder shapes. The surface dances
with color against the darks with the
round shapes adding to the effect,
while the diagonal acts as a stabi-
lizer and divides the painting for
an interesting composition.

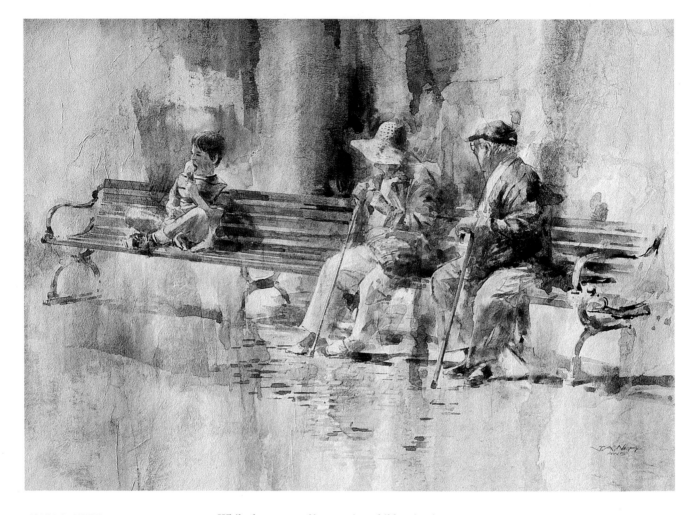

JOHN A. NEFF
Ice Cream
20" x 28" (51 cm x 71 cm)
Tissue mounted on double-thick board

While the center of interest is a child eating ice cream, the figures to the right were included for composition and added interest. The canes of the couple create a diagonal that leads to their heads. The elongated bench helps isolate the boy and the position of his legs draws attention to the ice cream. Free-flowing washes in and out of the figures help tie the shapes to the background. Simplicity is the keynote of design—this is what I strive to achieve in the composition of figures.

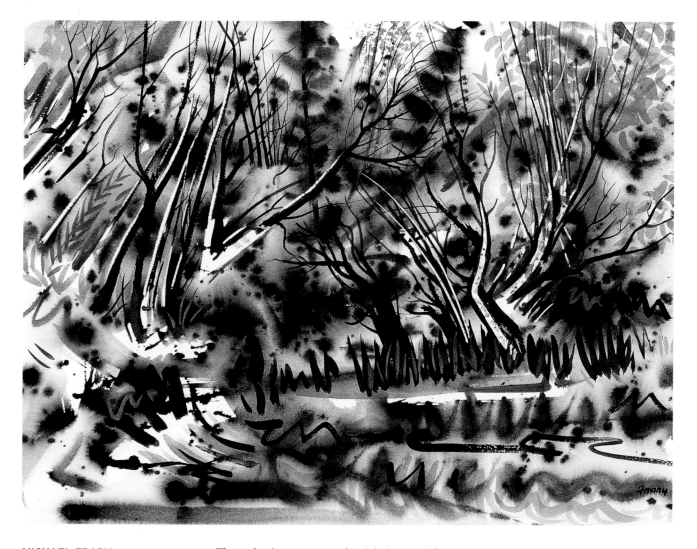

MICHAEL FRARY
Autumn
22" x 30" (56 cm x 76 cm)
Arches 140 lb. cold press

The path of movement and weight in pictorial space is
a very important part of painting. Movement in *Autumn*
is clockwise, moving from lower-right to left, where it
meets the solid mass of black and white, then up through
the tree trunks to the parallel branches to the right. The
movement is caught by the branches and the cadmium
red; it then turns down, and converges to meet the vertical
brushstrokes and the white of the middle distance, adding
to the foreground movement to the left, completing
the cycle.

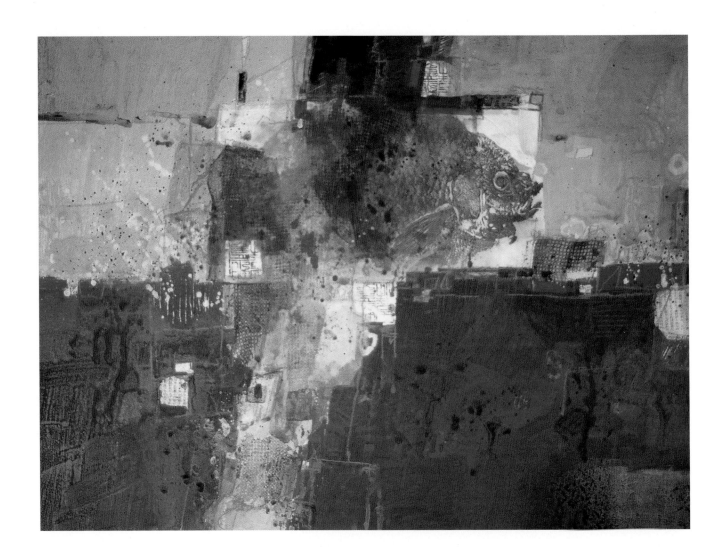

DONNA WATSON
Haiku
20" x 26" (51 cm x 66 cm)
Crescent watercolor board hot press
Watercolor with gouache, collage,
and crayon

My paintings are semi-abstract with Asian themes and subject matter, so space division becomes essential. I divide the space according to light areas and dark areas, balancing the different parts of my painting. I try to move the viewer through the piece with either a pattern of lights or darks. I carefully plan my paintings to achieve an Asian harmony; I balance quiet space with busy, textured areas for excitement and interest. Each piece of collage is added keeping space division and balance in mind.

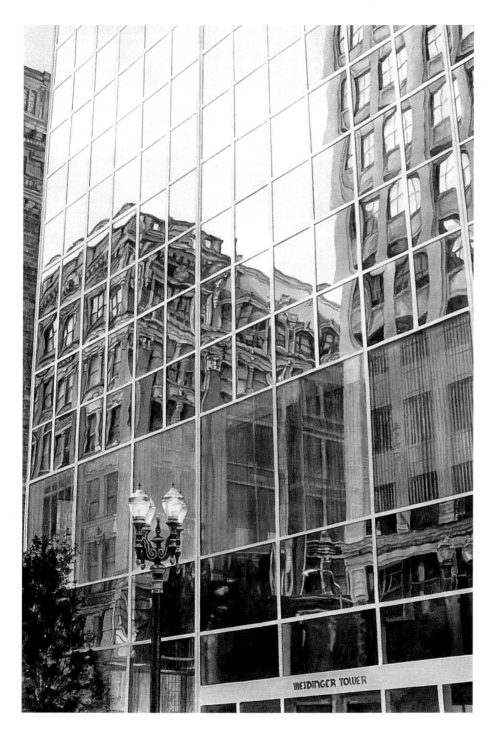

KATHLEEN PAWLEY
Galleria Growing Panes
38" x 26" (97 cm x 66 cm)
Arches 260 lb. cold press

*Collection of KFC Corporation,
Louisville, KY*

Oversized paper was selected to best express the size and skyward thrust of the building. The diminishing perspective posed a challenge in masking off the light bands framing the windows to allow a continuous wash of sky colors. After the tape was removed, the inner shadow areas of each window were defined by running a dark line of color with a fine-pointed sable brush along a metal ruler to retain the sleek look of the contemporary building. The composition was planned to mirror the undulating reflections of the old, ornate architecture adjacent to the window walls of this new galleria.

JOEY HOWARD
Spark V
15" x 11" (38 cm x 28 cm)
Arches 140 lb. cold press
Watercolor and gouache

The entire composition of *Spark V*, while arrived at intuitively, is built from a strong, upward-thrusting vertical that begins with the large tree and extends toward the white lines of the starlight above. In creating my paintings, I begin with a few light marks on the paper to place the major forms, and then I work spontaneously, letting one thing lead to another and trying to respond to the composition as it develops. While that process is largely intuitive, it is based on a strong desire for movement, balance, and rhythm in the finished picture.

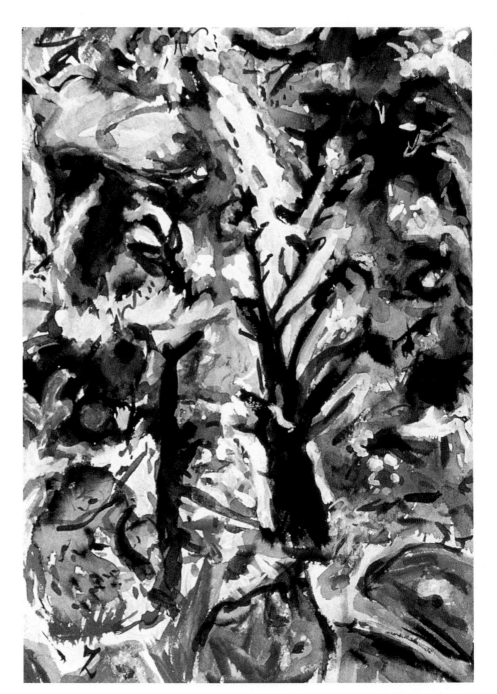

HENRY FUKUHARA
Playa del Rey
18" x 24" (46 cm x 61 cm)
Winsor and Newton 140 lb. rough

Faced with the many visual facets of the terraced residential site, the challenge became simplifying the subject. Looking for large related shapes, doing a number of preliminary value studies, placing the positive in relation to the negative shapes, having the whites read well to attract the viewer, placing darks to secure balance of values, and creating movement and overlaps to give distance and perspective are all part of my technique.

EUDOXIA WOODWARD
Cauliflower Configurations
24" x 18" (61 cm x 46 cm)
Arches 140 lb. cold press
Watercolor with graphite and
colored pencil

Cauliflower Configurations is a visual
translation of the geometric forms
inherent to cauliflower. The spatial
composition resulted from individ-
ual clusters cut off from the main
body of the plant, ascending into the
deep blue sky, diminishing in size.
They were created with watercolor
airbrush and stencils. The inherent
spirals and pentagonal shapes help
create the sense of movement and
space.

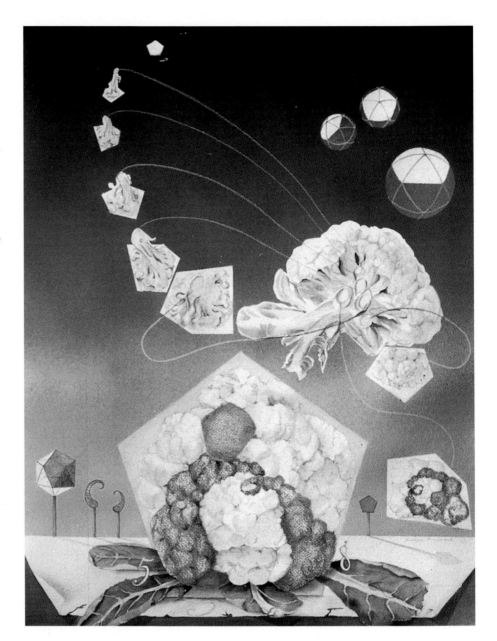

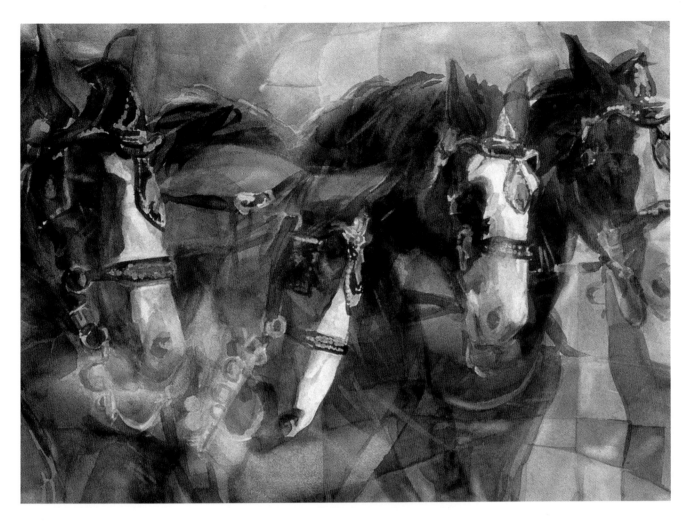

ELLEN JEAN DIEDERICH
Working Action
21" x 29" (53 cm x 74 cm)
Arches 140 lb. cold press

Four draft horses create one large interesting shape across *Working Action*. While the composition is basically static in design, the active, curved, irregular grid interrupts the design, ties the horses to the background, and shows the grace and strength of the horses united as a force. In an effort to strengthen the drawing, I scrubbed out under the second horse to create the illusion of breath. The background was softened to relate the grid to the horses. A series of lines, dots, shapes, and textures creates an exciting composition.

JOANNE AUGUSTINE
Prelude to Winter
33.5" x 25.5" (85 cm x 65 cm)
4-ply museum board smooth

I found the ethereal quality of these fragile sunflowers standing at the edge of a deserted garden at the end of their lives very moving. Painting flowers in all stages of their life cycles suggests a metaphor for our own lives. I dramatized the differences in heights, sizes, and positions of the stalks and varied the spaces between plants to create the desired composition. Curves at the top of the stems as the flowers' heavy heads drooped added rhythm. To create the mood, I used grayed colors and non-staining pigments so I could lift the whites. Throughout the process, I reminded myself that less is more.

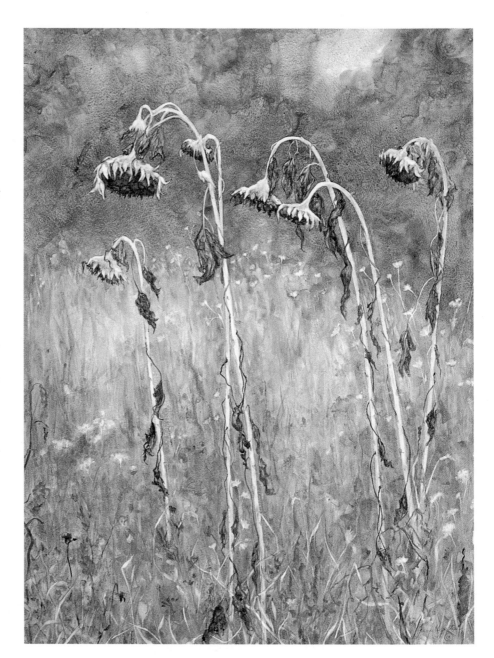

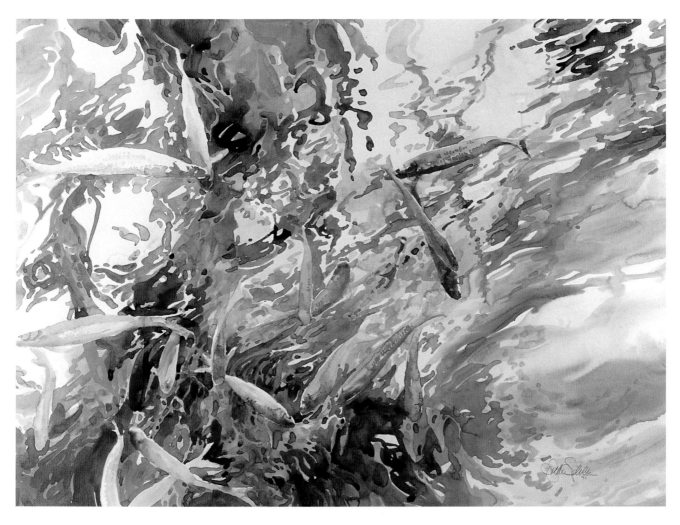

SUSAN SPENCER
View Through the School Window
28" x 36" (71 cm x 91 cm)
Arches 300 lb. cold press

I always begin a work with close observation of the world around me, thinking through compositional aspects with value sketches in ebony pencil, and making decisions on the broad concept of the design. The unusual fish-eye viewpoint of this painting grabs the viewer's attention. Rather than using any flashy technique, I rely on clean execution to create the illusion of looking up through the moving water. Composition holds the painting together while reinforcing water's movement and refraction.

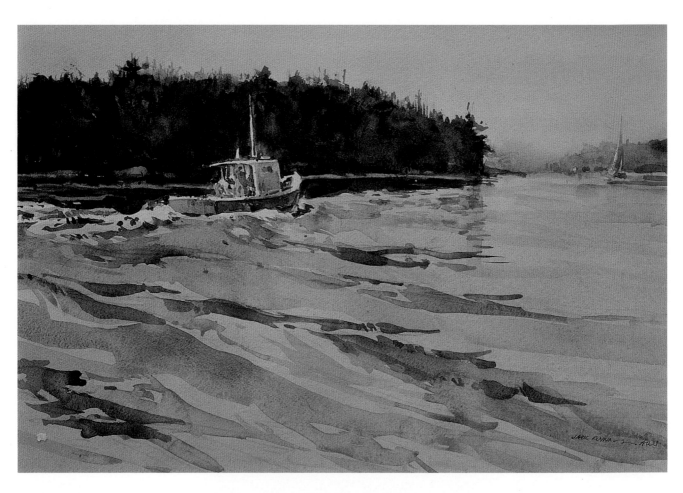

JACK FLYNN
Going Home
15" x 22" (38 cm x 56 cm)
Arches 140 lb. cold press

Shadows help define the shape and contours of objects they fall across. Everything in *Going Home* is seen in light, however subdued, so all objects have a light and dark side to them. The shadow side picks up colors and reflected light from everything around. Watercolor is fluid and fast-drying and it depends on the paper for its transparency with each pigment having different properties. I work with a limited folding palette and just a few brushes.

DAVID R. DANIELS
Watermelon
31" x 27" (79 cm x 69 cm)
Crescent board

Hue, value, and chroma catch the immediate attention of the viewer, but it is the strength of the composition that invites them to become involved with the piece. In *Watermelon*, it is the strong diagonals of the blades of grass and the curves of the melons that direct the viewer through the painting. While at the farmers' market, I became fascinated with the texture and subtle beauty of the watermelons on display. I purchased one and created an outside still life with additional plants from my garden, photographing it for reference. I worked wet-in-wet, using staining and non-staining watercolors, vigorously scrubbing the watermelon for texture.

STEPHEN M. BLACKBURN
Forgotten Treasure
12" x 18" (31 cm x 46 cm)
Arches 300 lb. hot press

For my style, which employs painting from the inside out, I use a pattern of darks in the negative space around the center of interest to create movement through the painting. Relatively light subject matter, such as the hobby horse of *Forgotten Treasure*, attracts me. A series of photos of discarded items were used in the background to create a pattern of color and dark values. This helps lead the eye through the piece diagonally and then back to the center of interest in the upper-right corner. Variation in size of light and dark values created a dynamic pattern, with the darkest values under and behind the horse to give direction.

JUDY D. TREMAN
Fanfare
40" x 29" (102 cm x 74 cm)
Arches 300 lb. rough

The complexity of the stripe patterns in the blossoms, vase, and serape give a heraldic quality to *Fanfare*. The interplay of stripes on stripes—in the flower petals, the pattern of the vase, and within the serape—keeps the viewer's eye moving at all times. At the same time, the centered vase serves as an anchor for this strong composition while shadows give substance to the contoured forms, and lead the viewer around the painting.

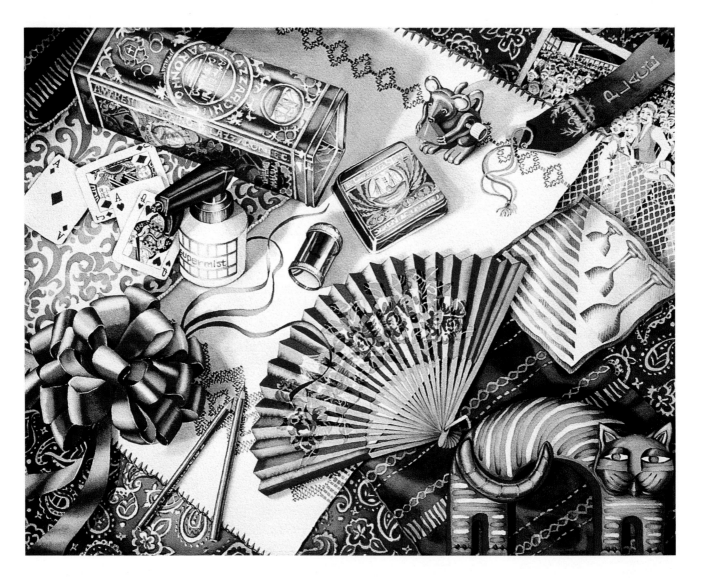

JOYCE GRACE
Red Games: Pushing My Luck
22" x 30" (56 cm x 76 cm)
Arches 300 lb. cold press

Red Games: Pushing My Luck is the first of a series about the games people play and the emotions colors evoke in us. In this case, games of love, luck, lust, and risk called for the use of red. Placing the cat squarely on the lower-right edge of the painting could have been a compositional barrier, but repeating semi-circular and circular forms along with strong diagonals keeps the viewer's eye moving. Since the color and content of the piece called for risk, I wanted to make a strong statement. The viewer experiences a visual tour, traveling from the cat around the painting counter clockwise, pausing at each item before moving on to the next image.

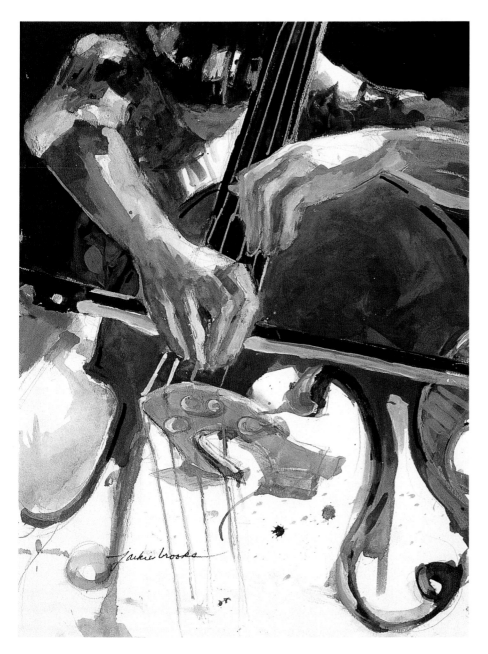

JACKIE BROOKS
Young Bassist
24" x 18" (61 cm x 46 cm)
140 lb. cold press
Watercolor with gesso

Although the Polaroid snapshot of my bass-playing son Jeff was taken a number of years ago, it was only recently I saw possibilities for a painting. Often a Polaroid photo loses darks and lights so everything has a flat appearance. After doing value studies in which I created my own source of light, I envisioned a strong painting. The body language influenced the decision to place emphasis on Jeff's posture, instrument, and mainly on his hands, which I exaggerated in size. Creating this painting made me realize that sometimes an imperfect original can set me free to be an interpreter.

FRANK FRANCESE
Vecchio Varzi, Italy
15" x 11" (38 cm x 28 cm)
Saunders Waterford 140 lb. rough

Using the dark, narrow streets and colorful buildings of Varzi, Italy, I pull the viewer into the composition by arranging the dark values of the shadows over the pure color of the buildings. The viewer's eye is directed to the brilliant white of one building, which is the center of interest. To show a sense of scale, I left a few areas of white in the lower portion of the painting to depict the movement of people.

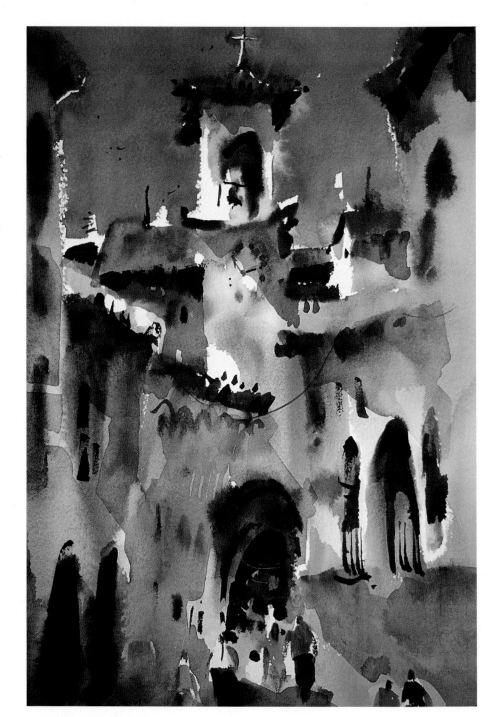

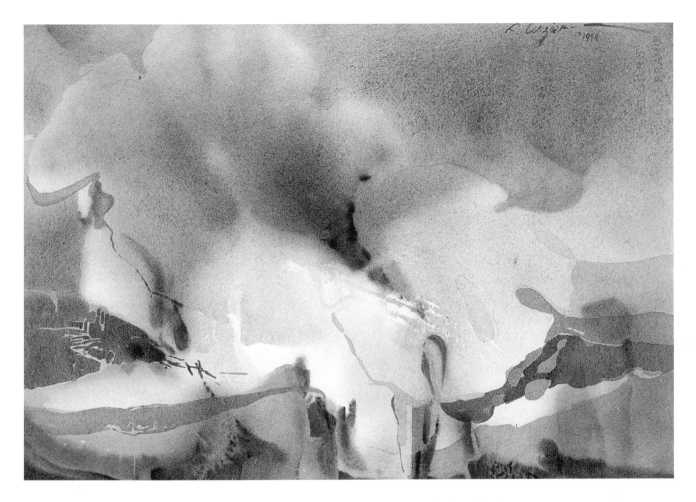

SUSAN LUZIER
Pacific Shades #3
15" x 22" (38 cm x 56 cm)
Arches 140 lb. cold press

For me, the most important part of painting is the spiritual aspect. If you enjoy the process of painting and turn your thoughts away from outcome, the art will emerge in its own time and way. Listening and responding to the moment of inspiration is the secret. Techniques of my paintings include dropping of color, wet-in-wet, and glazing interlocked and overlapped shapes in conjunction with good design and textural overtones.

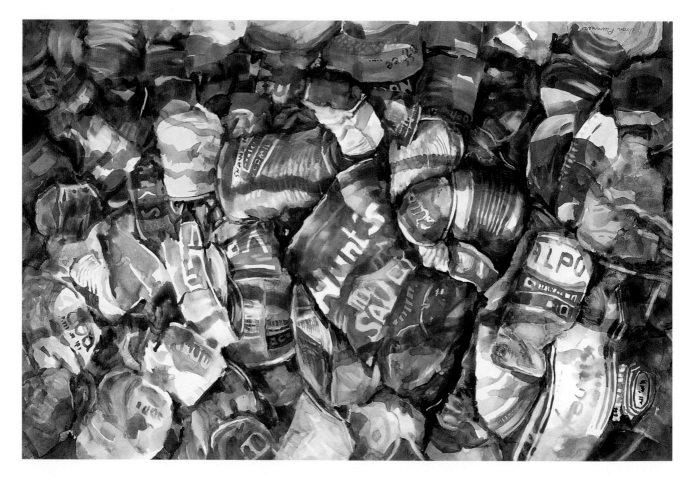

JOAN M. PLUMMER
Recycle I
20" x 30" (51 cm x 76 cm)
Strathmore illustration board

When painting *Recycle I*, I wanted to convey an environmental image to the viewer. I started with large, watery areas of color that were later woven together to suit the composition. Since my picture plane consisted of shallow space, a variety of lost and found edges played a key role in making a rhythmic movement through the maze of shapes. Alternating light and dark passages added further momentum to the design. By manipulating the relationships between these positive and negative shapes, I further emphasized the impact areas.

AVIE BIEDINGER
Smarter Than a Tree Full of Owls
22" x 30" (56 cm x 76 cm)
Arches 140 lb. cold press
Watercolor with acrylic, watercolor
crayons, and collage

Smarter than a Tree Full of Owls began as a non-objective transparent watercolor; but, as the painting progressed, collage—in the form of magazine pages and torn water-color and rice papers—became the natural metamorphosis. Scribbles, acrylic washes, and watercolor crayons added visual appeal to the carefully developed shapes. Essential prominent rest areas dominate the composition while small squiggle sections signal movement.

SABINE M. BARNARD
Thomas' Pond
22" x 30" (56 cm x 76 cm)
Arches 300 lb. cold press
Watercolor with gouache

I used the subject matter as a means of conveying a moment of serenity—a quiet observation point in the midst of natural beauty. Up close, the subject matter includes a bit of fantasy, as one might be inspired to see while gazing at the scene. The stylized fish border is a playful depiction of what might be underneath the water's surface.

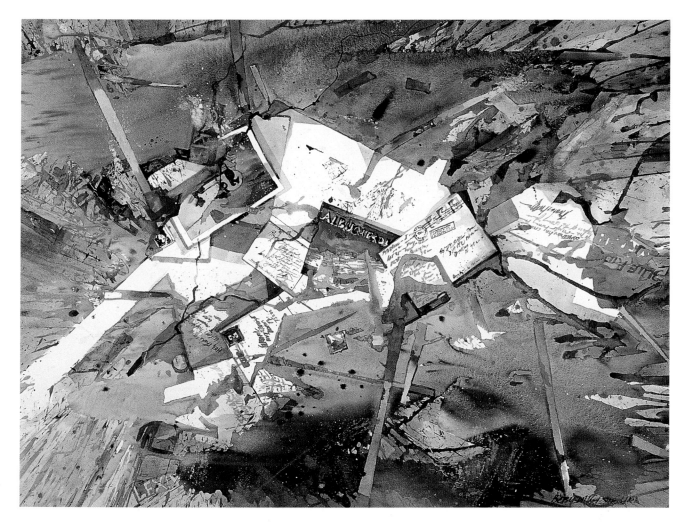

BETSY DILLARD STROUD
Postcards from the Edge #7
30" x 40" (76 cm x 102 cm)
Crescent 114 cold press

My poured card paintings are related to quantum physics, by organizing structure (space and composition) out of chaos (spontaneous and intuitive pouring, dripping, and sometimes throwing of paint). Transparent watercolor's special properties lend themselves to unexpected and exciting color diffusions, and the natural movement of the medium reflects my own rhythms as I move around the piece pouring paint. The postcards, which are symbolic and representational, bridge the gap to abstract surroundings.

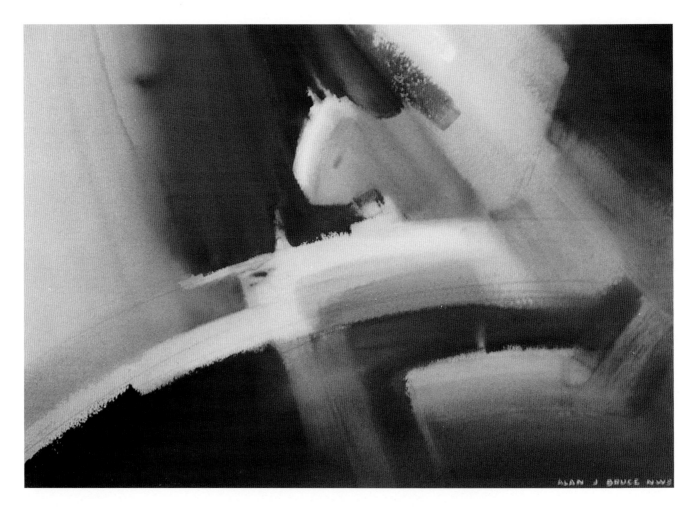

ALAN JOHN BRUCE
Squirrel Pattern #1
20" x 28" (51 cm x 71 cm)
Arches 140 lb. rough

The patterns in this painting were established with strong brushwork that accentuated the light. I tried to simplify the forms and use the natural texture of the rough paper, using a pure-pigment palette of colors and large 1-inch and 1.5-inch flat brushes. The squirrel was painted first and then the secondary abstract areas were established with an eye toward balancing color, texture, and design. I hoped to achieve the sense of rhythm that one associates with music or poetry.

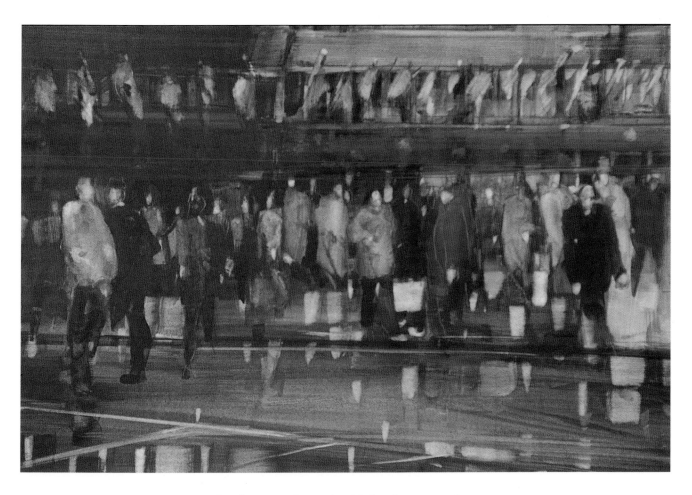

ALFRED CHRISTOPHER
The Flagmen
10" x 15" (25 cm x 38 cm)
Strathmore 500 series

A well-composed space is critical to the success of any work of art, and the process of achieving successful composition requires the artist to juggle both positive and negative space. In striving for a well-composed picture, I first choose a subject and determine the feeling I want my picture to convey about it. I then select the materials that will support that expression and begin applying pigment, always evaluating my last action so that each new stroke of paint will make a correction or adjustment to the painting that supports the composition.

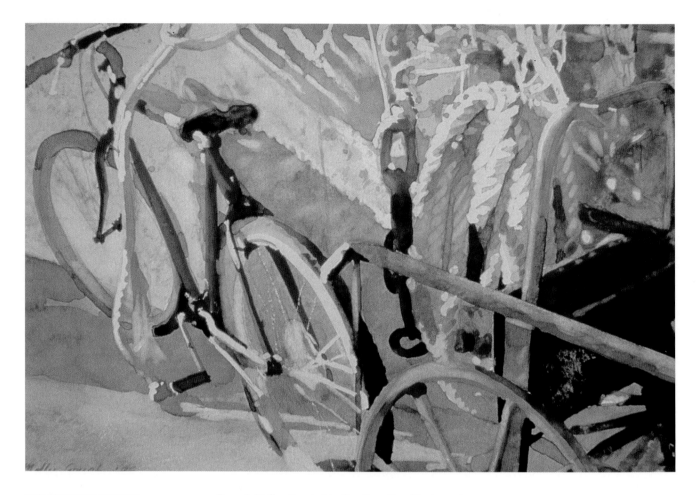

MOLLY DAVIS GOUGH
Italian Textures
7.75" x 11.75" (20 cm x 30 cm)
Strathmore 4-ply bristol
Watercolor with gouache

I was initially attracted to the diversity of textures in this subject. A combination of color washes, spattering, removal of color, and scratching were used to express the textures. Cropping just a small area of the scene enhanced the impact of the composition. Movement of darks and lights, as exemplified by the ropes that seem to move against a rock wall, was emphasized by the smoothness of descriptive textures against the roughness of other planes in the picture.

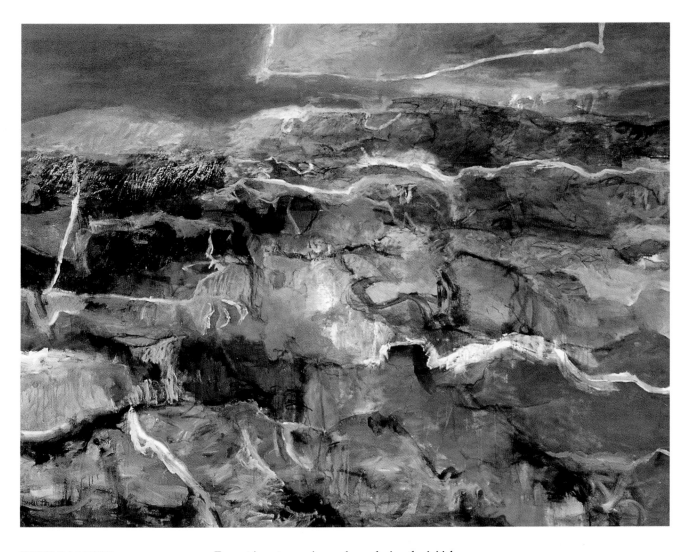

HAROLD LARSEN
Desires II
30" x 40" (76 cm x 102 cm)
Strathmore 140 lb.
Watercolor with acrylic

Format is not my primary focus during the initial process of painting. Only after allowing the creative force within myself to exert its influence do I become aware of composition, then it becomes a corrective instrument. Composition is a tool to achieve the mood of a painting, whether the work conveys serenity or tension. Toward the end of a painting, I might make corrective steps by adding or eliminating things.

BARBARA SCULLIN
Nature's Mystery
20" x 30" (51 cm x 76 cm)
Arches 300 lb. cold press

Nature is a major influence on my shapes and compositions. My paintings look into nature, not at it, and the references to nature should be sensed rather than recognized. In *Nature's Mystery* there is a spatial excitement in the light shape that draws the viewer into the painting. My aim was to attract viewers with a bold and dramatic composition and hold their attention with the subtleties of line and rhythm. Color, line, and shape were carefully placed and interwoven, holding it together.

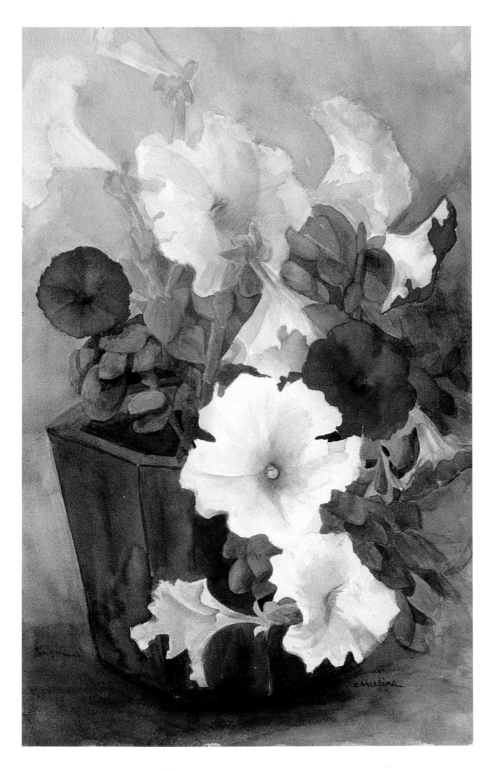

AUDREY H. HARKINS
Petunias
21.5" x 14" (55 cm x 36 cm)
Arches 140 lb. cold press

When painting flowers, composition is one of the most important aspects. Placement of each blossom takes the viewer's eye through either a whole garden, a bouquet, or a single flower. I try to capture the essence of the flower, each variety having its own symphony of movement and color. Starting with a careful drawing, I applied pure watercolor wet-in-wet, contrasting the softness and delicacy of the petunias with the textured old wood of the container.

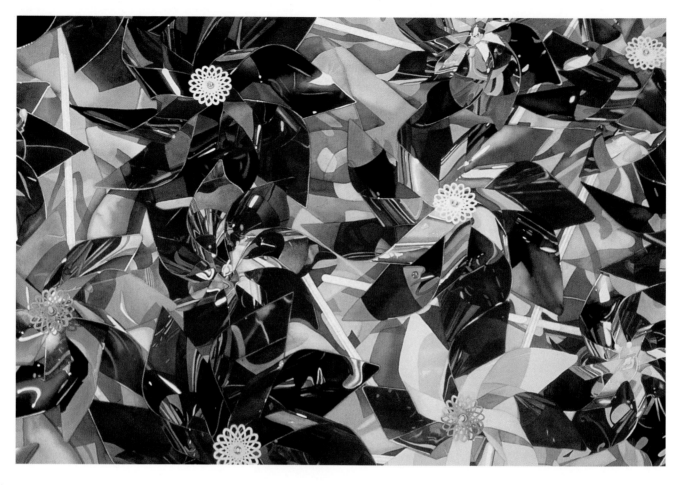

ELLEN MURRAY
Pinwheel Painting #3
39" x 59" (99 cm x 150 cm)
Arches 300 lb. cold press

Pinwheel Painting #3 began with an idea for an overall composition in which no single object would dominate. Pinwheels were selected for their unique abstract form that implies wind, movement, and freedom in space. Strong colors and reflective qualities were emphasized as a sharp counterpoint to the neutral gray background and shadows and to separate the pinwheels from the spatial confines of their background. The close proximity of each object, as well as the arrangement of the handles, helps define a sense of movement across and through the composition.

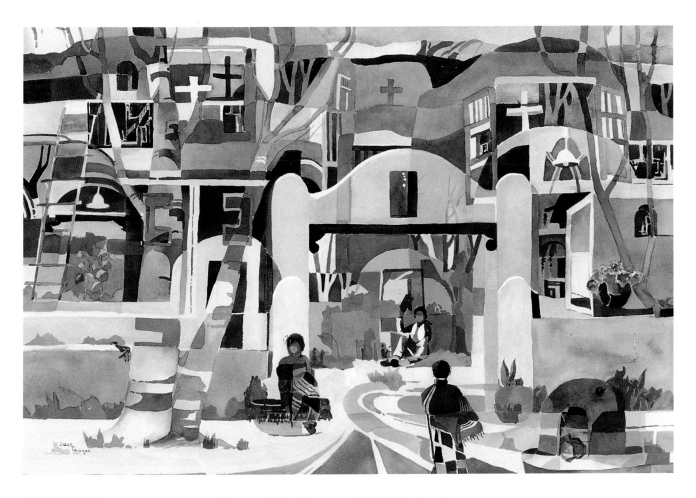

DEAN TEAGUE
Homeward Bound
22" x 30" (56 cm x 76 cm)
Arches 140 lb. cold press
Watercolor with gouache

Homeward Bound represents the Native American passage to a place of peace and rest. By superimposing the gate over the mountains, trees, churches, and buildings, space is used in a unique way, adding a surreal dimension and showing we are one with nature. As I painted in watercolor and gouache, I changed color or value each time I crossed a line. An overall value pattern was developed by using values from zero to ten. Space and movement added a mystical feeling and drama to the painting.

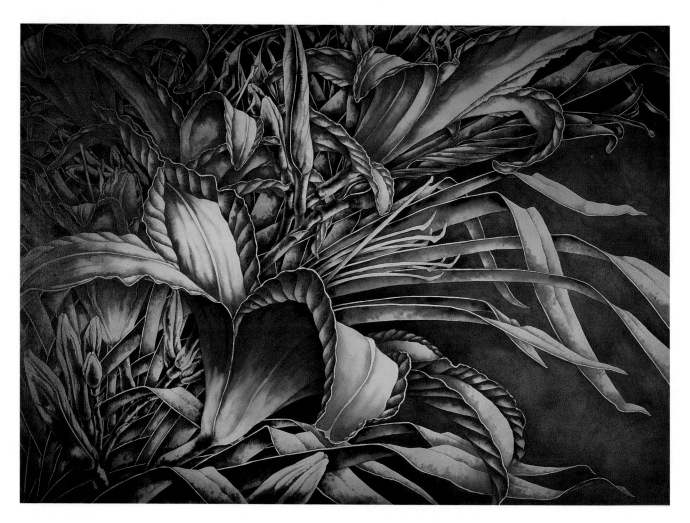

JOHN POLLOCK
Tinted Light Complications
29.5" x 41" (75 cm x 104 cm)
Arches 555 lb. cold press

I frequently use day lilies as the subject of my paintings because of the variety of shapes, colors, forms, and complexities they afford that can be transformed into an effective composition. In this picture, the composition centers around the placement of the large lily. Several other elements emphasize the linear movement radiating from the flower, as well as the interlocking and overlapping shapes. All these elements work together to create unity, dominance, movement, and balance.

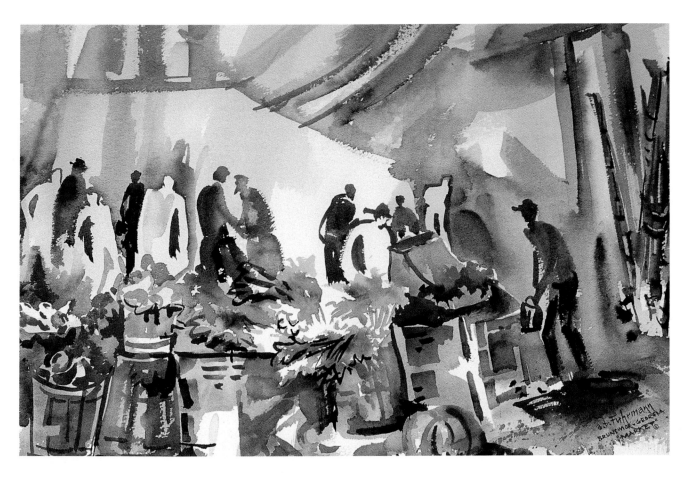

ALFRED B. FUHRMANN
New Orleans, Market Place—
Vieux Carré
15" x 22" (38 cm x 56 cm)
Arches 300 lb. rough

This was a very challenging painting because it was done on location with people and traffic in constant motion. No one was posing for the work, so quickness of thought, color choice, composition, and delivery of watercolor techniques were key motivations. Wet-in-wet and wet over dry surfaces were utilized while maintaining simplicity.

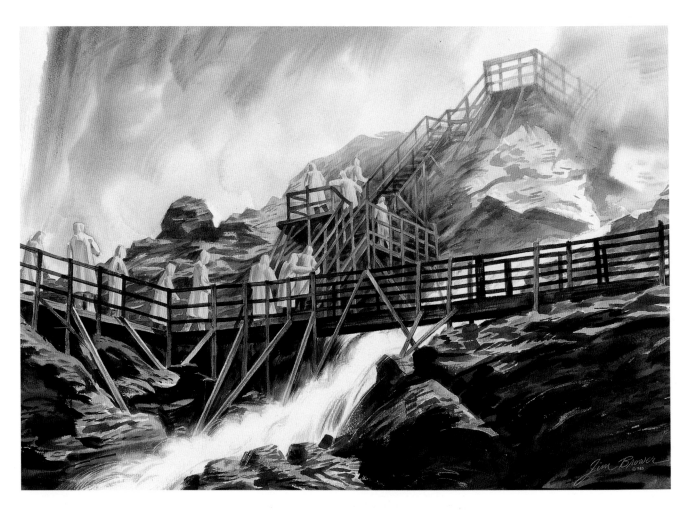

JIM BROWER
Beneath Niagara
20.5" x 29.5" (52 cm x 75 cm)
Fabriano 300 lb. cold press

Several visits to Niagara Falls have provided reels of movies from frames of which this watercolor was painted. I liked the spatial division and strong diagonals resulting from the downward movement of the water and position of the rocks as opposed to the upward movement of the figures. The strong color contrast provided by the vivid yellow raingear was appealing. Experience has conditioned me against any fortuitous approach to watercolor, therefore, all effects and textures are strictly brush-controlled.

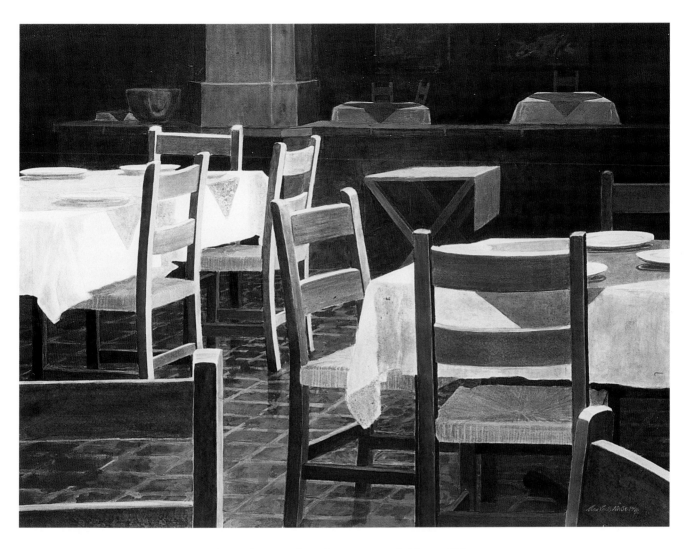

ARA LEITES
End of the Day
22" x 30" (56 cm x 76 cm)
Lanaquarelle 80 lb.
Watercolor with acrylic

As an abstract painter, I try to use real objects within an abstractly designed picture plane. In this case, I placed objects using the rebattment principle of the golden section. That is, the relationship of a square to a rectangle that encompasses it. This is a left rebattment, where the left edge of the column lines up with the back of a middle-ground chair and then to a foreground chair to artificially form a square on the remaining right side of the picture plane.

MELISSA ADKISON
Purples First
27.5" x 21" (70 cm x 53 cm)
Arches 140 lb. cold press

Throughout *Purples First*, soft red roses against the linear pattern of a Mexican blanket were enhanced by purple shadows. Watercolor's translucent qualities allowed me to capture subtle glass reflections. Shadows were created by first applying layers of alizarin crimson mixed with cobalt blue or ultramarine blue first and then applying the local color over that area. The final result was accomplished with a combination of flat washes and wet-in-wet techniques. The colorful stripes of the blanket flowed directly to the roses, which then created shadows that draw the viewer deep into the painting.

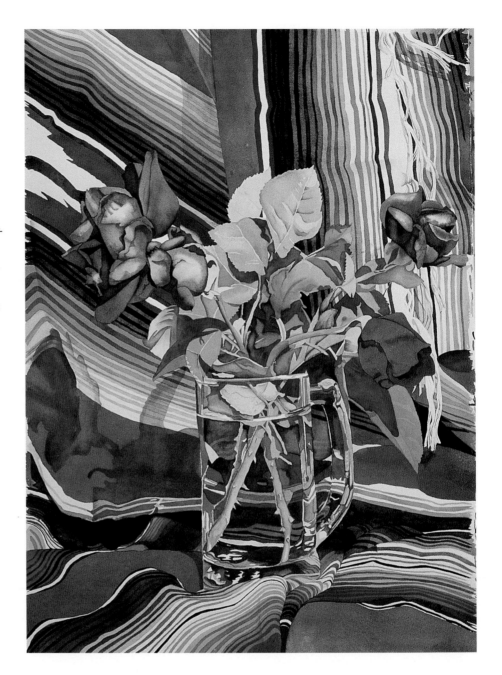

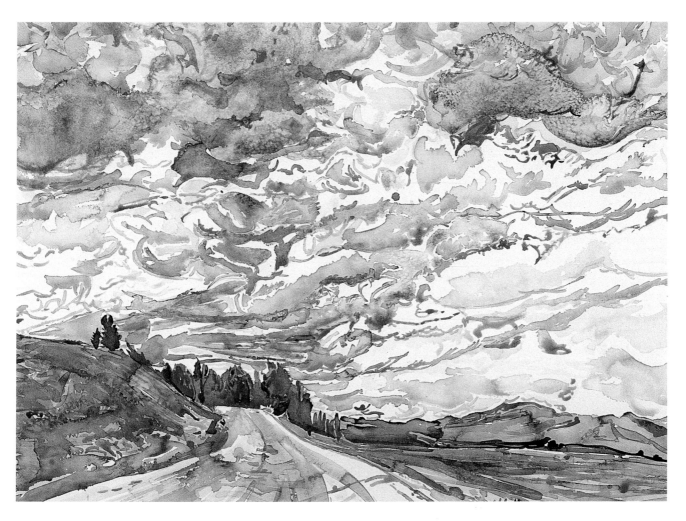

LYNN GADAL
Cloud Symphony
20" x 28" (51 cm x 71 cm)
Arches 300 lb. cold press

The image of *Cloud Symphony* came to me in a dream and was so strong, I woke up and went to my studio to draw it. Clouds move and change continually while the landscape below remains stationary. Working wet-in-wet and overlapping several colors created an illusion of form and movement. Salt was used to achieve the desired look in the clouds. Tying in line and shape, as well as color contrast, helped to define the composition of this painting.

JACKIE MAY
Nine-to-Five
19" x 15" (48 cm x 38 cm)
Strathmore 500 series
Watercolor with acrylic

Observing images within an office complex inspired me to paint *Nine-to-Five*. The various shapes and their relationships to one another were the springboards for my imagination. I began by designing the larger geometric spaces, then the reflected shapes were interwoven and layered in transparent and opaque passages to carry movement and interest throughout the work. Acrylic paints on smooth illustration board allowed me to achieve interesting textures and a great sense of dimension.

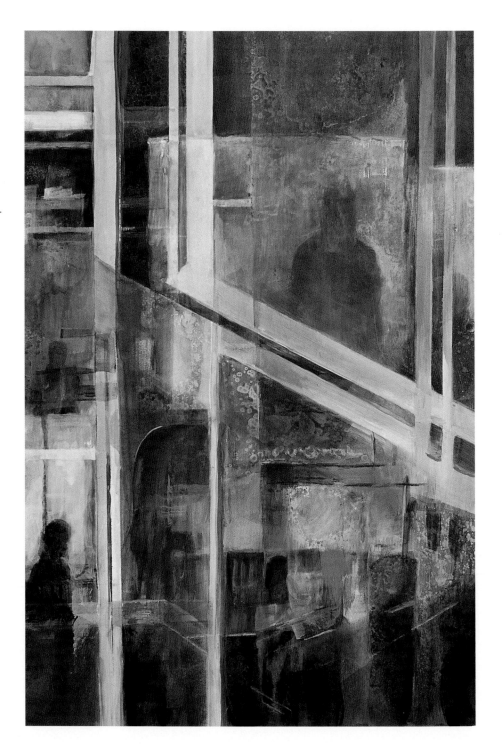

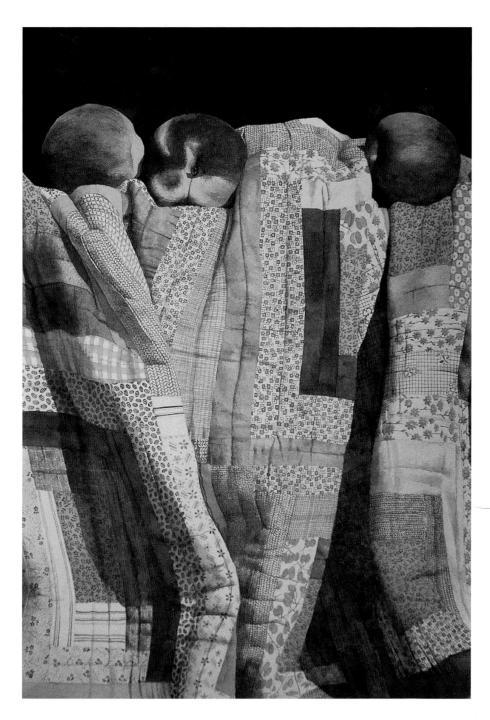

CHRIS KRUPINSKI
Peaches on an Old Quilt
30" x 22" (76 cm x 56 cm)
Arches 300 lb. rough

I try to approach still lifes by seeing them in a different way. In the case of *Peaches on an Old Quilt*, I created a high horizon as one way of approaching the subject in a new way. Usually draped cloth in a still life is used for background purposes only, but since I love to paint quilts, I made it the primary feature. The quilt invites you into the painting and the fruit gives definition. I selected an analogous color scheme to unify the entire painting.

DIANE J. O'BRIEN
Crimson Pride
30" x 22" (76 cm x 56 cm)
Winsor and Newton 260 lb.

I am an intuitive painter and my main objective in *Crimson Pride* was movement. Using lights, darks, and values woven throughout the painting leads the viewer in a dance of movement through the composition. Pure watercolor glazing and layering with loose washes of flowing color were my primary techniques. Negative painting finished the piece.

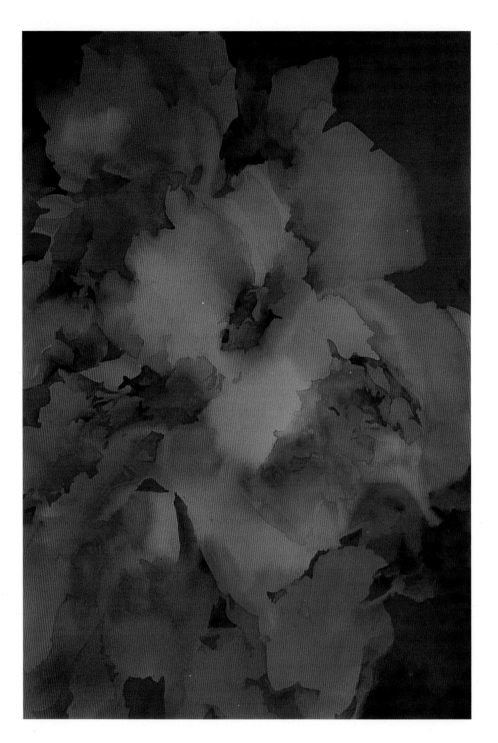

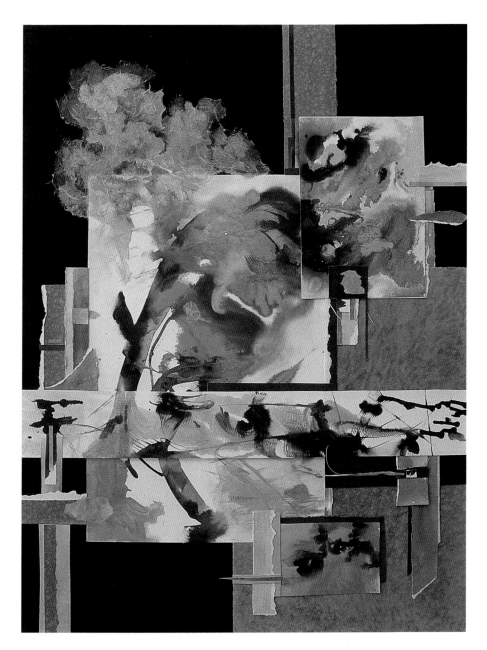

RENÉE FAKHRAI
Storm
38" x 30" (97 cm x 76 cm)
Aquarius II 90 lb., Arches 140 lb.,
Arches 300 lb., and foam board
Watercolor with acrylic inks and
water-based enamel

Using an exciting color combination
and a dynamic composition, I
sought to achieve simultaneous
movement and drama. I began with
separate pours on different sizes of
paper, painting with water first then
dropping in inks and watercolor. A
comb was run through the wet paint
in places to create movement and
texture. Other papers were painted,
then placed outdoors in the rain for
a splotched, watery effect. Depth
was achieved through raised layers
of underlying mat board, different
depths of rice paper, and opaque
and transparent paints set against
one another.

LANCE R. MIYAMOTO
Hope
24" x 19" (61 cm x 48 cm)
Arches 140 lb. rough

The subject of *Hope* represents woman emerging from the darkness. Watercolor was chosen for its fluidity and ability to respond instantaneously to current emotion. Wet-in-wet technique was used to create the illusion of the figure in a moist and secluded wooded area with light filtering through. Contrasts of light and shade projected the image forward and allowed the head to emerge.

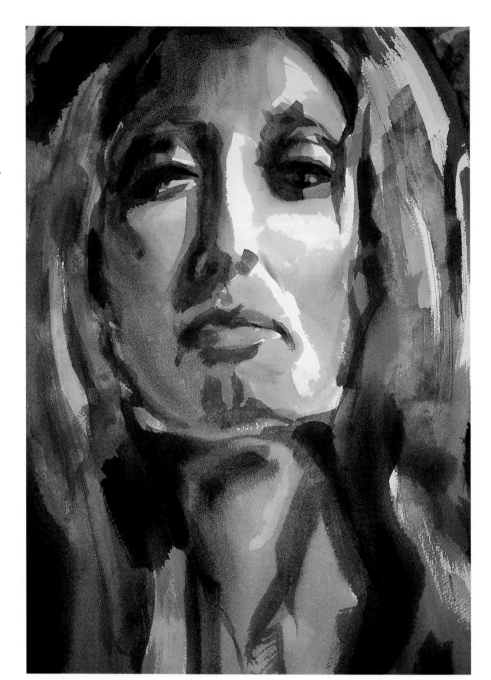

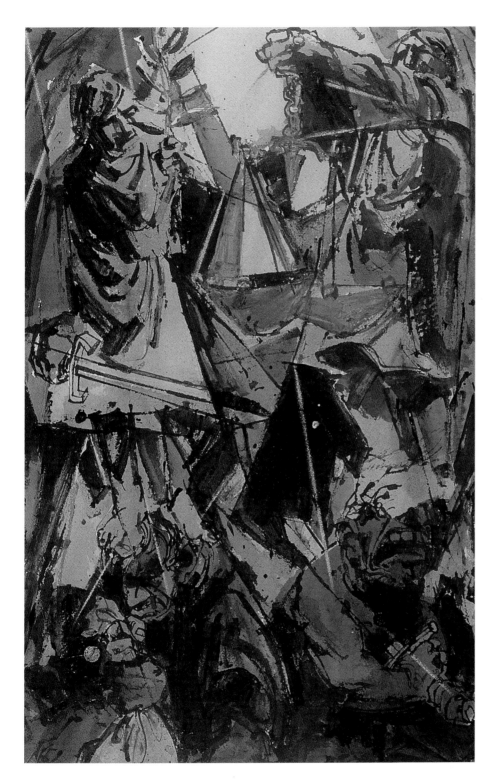

JOHN A. LAWN
Equity
28" x 17" (71 cm x 43 cm)
Arches 140 lb. hot press
Watercolor with acrylic and ink

A seventeenth-century stained glass church window was the inspiration for *Equity*. I wanted to develop a composition with a strong right-to-left movement and counter-movement. After establishing basic color passages with watercolor, I used the handle end of brushes—sharpened to a chisel-like point and dipped into ink—for picture detail. This was followed by development with acrylic, using black to further focus on the concept of the painting.

EDWARD MINCHIN
Refracted Light
36" x 29" (91 cm x 74 cm)
Arches 140 lb. cold press
Watercolor with acrylic

Through experimentation and allow-
ing the painting to lead, I was able
to discover a strong landscape idea.
Spontaneous washes of watercolor
were applied with no subject or
composition in mind. As the paint-
ing progressed, the tree shape
emerged, with all the strength
focused at the top of the work.
Details such as rocks and plants
fell into place naturally. Acrylic
glazes accentuated the intensity of
color over the soft washes, exagger-
ating the warm mood by using pre-
dominantly warm colors with a hint
of cool tones.

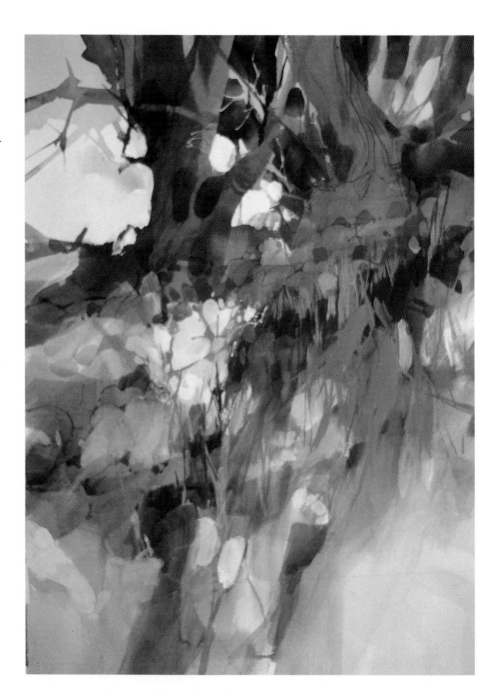

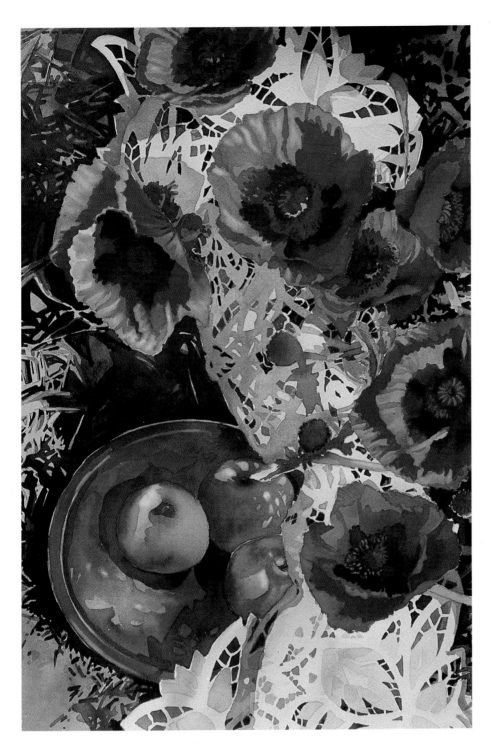

NANCY L. BALDRICA
Lace and Life
30" x 22" (76 cm x 56 cm)
Arches 300 lb. cold press

Because Oriental poppies wilt quickly, I gathered together the bowl, lace, and Granny Smith apples and made my arrangement in the flower bed. I chose an overhead view for the interaction of shapes, textures, and shadows. The lace texture was repeated in the grass, poppy leaves, shadows, and on the apples; the curvilinear shapes of the bowl, apples, and poppies added contrast to the textural elements. Complementary colors, red and green, were used primarily, with many subtle color variations in areas such as the lace. Reflecting blue within the red bowl suggested the overhead sky and created the feeling of space.

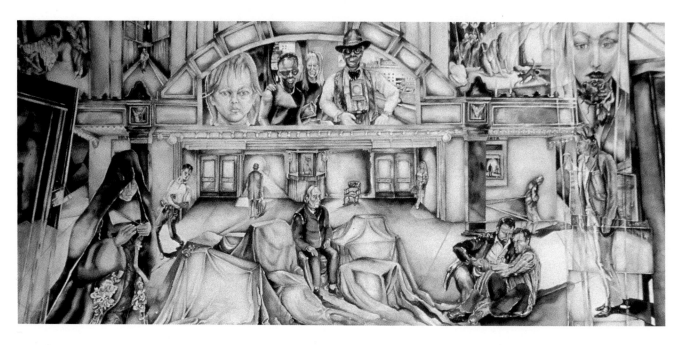

GLENDA K. FOLK
Street of Stars
44" x 96" (112 cm x 244 cm)
Arches 140 lb. rough

Street of Stars is one of a series of forty paintings based on my experiences as a performing artist working in films, television, and live theater. I needed a large sheet of watercolor paper for the painting because of the complexity of the image and because of the physical impact I wanted it to have on the viewer. The length of the painting gives viewers an opportunity to contemplate the social extremes, anxieties, desperation, and vulnerability of the actors playing their roles. The painting takes the viewers on a rhythmic, up-and-down journey through the world of thespian characters.

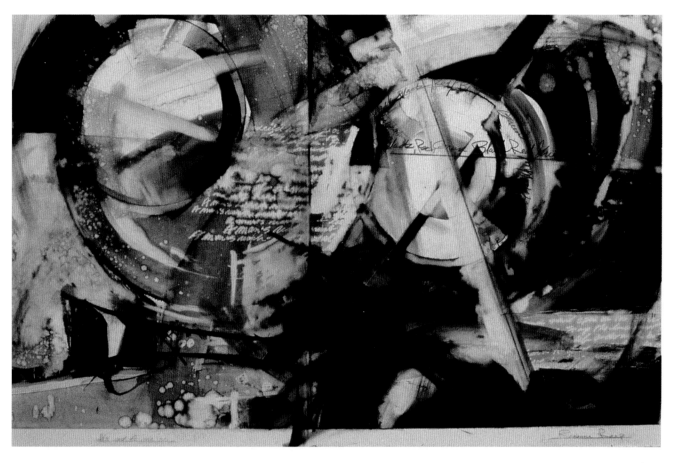

ROXANNE REEP
It's Red to Me
17" x 25" (43 cm x 64 cm)
Masonite board
Watercolor with acrylic

It's Red to Me is loosely based on the relationship of shapes, lines, and implied movement. A tempered white masonite surface, sanded and primed to develop a paper-like tooth, was used because the paints remain fluid longer than on paper or canvas. A feeling of space was achieved by applying layers of paint that created different visual levels. During the process, I used the characteristics of the paint, such as texture, relative opacity, edges, and lines. I pushed and pulled and manipulated the materials to enhance the illusion of space and movement in accordance with compositional continuity.

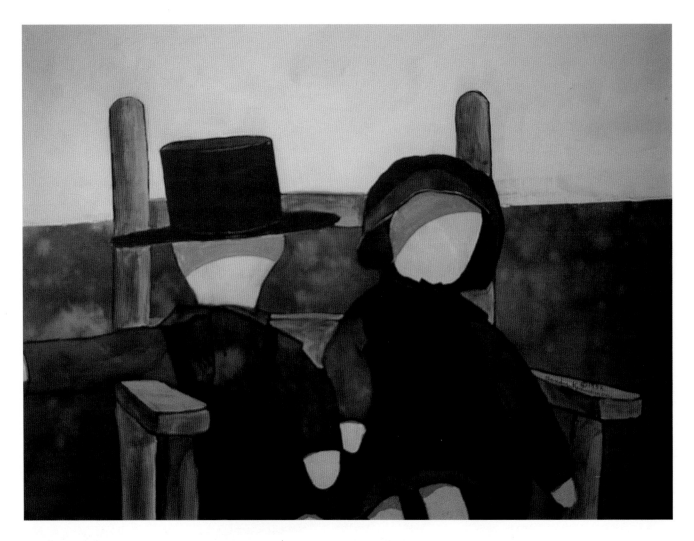

SANDY KINNAMON
Plain Dollies
20" x 27" (51 cm x 69 cm)
Illustration board
Watercolor with gouache

Growing up in rural Pennsylvania, I have always been fascinated with the Amish and their way of life. They believe in no graven images, therefore do not have photos taken, nor do they sew features on dolls' faces. Since the Amish dolls in *Plain Dollies* are so plain, texture was used in the background to add contrast and excitement. Gouache was used in the upper background as a resting area and it divides the background into two unequal parts. An interesting pattern of light striking the dolls' faces created shadows, which helped develop the eloquence of light on the otherwise featureless faces.

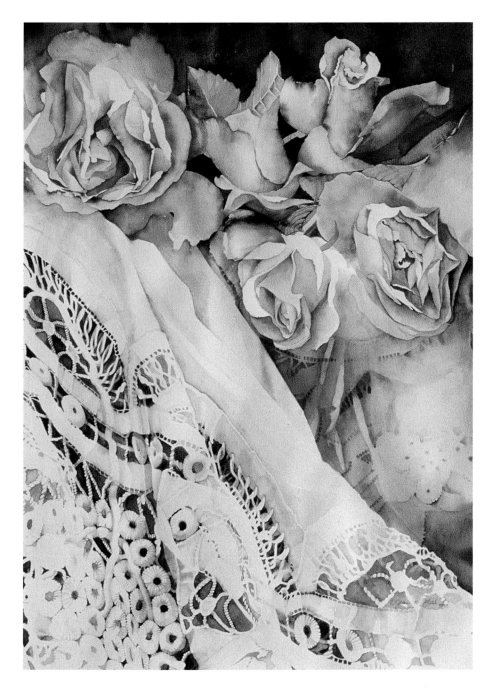

JEAN K. GILL
Battenburg Roses
30" x 22" (76 cm x 56 cm)
Winsor and Newton 140 lb. rough

Taking photographs allows me to consider various arrangements of still-life objects while I'm looking through the camera lens, and it helps me convert those three-dimensional shapes into two-dimensional planes of space in a painting. In composing this arrangement of roses and lace, I chose an asymmetrical balance, exaggerated scale, repeated curvilinear forms, and a strong diagonal thrust. The lace pattern was established by painting the negative spaces. When working with watercolor I challenge myself to make decisions about edges, value contrasts, and color distribution, and I alternate light and dark values at rhythmic intervals.

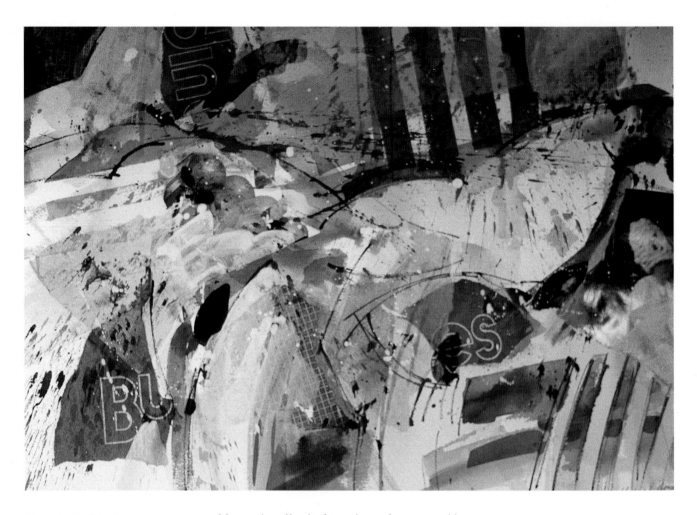

CLAIRE V. DORST
Abstraction #18
22" x 30" (56 cm x 76 cm)
Arches 140 lb. cold press
Watercolor with collage, India ink,
and gesso

My creative effort is always focused on composition, which need not be a complicated process. Most compositional elements need to be repeated several times to create rhythms that move the viewer's eye around the painting. Photos, shopping bag pieces, and colored tissue were collaged in *Abstraction #18* and freely painted watercolor was then applied in rhythms of balanced lights and darks to create the composition. I emphasized and textured certain light areas by flicking and drawing with India ink. A semi-transparent wash modified the harshness of the photos so they would retreat into the compositional whole.

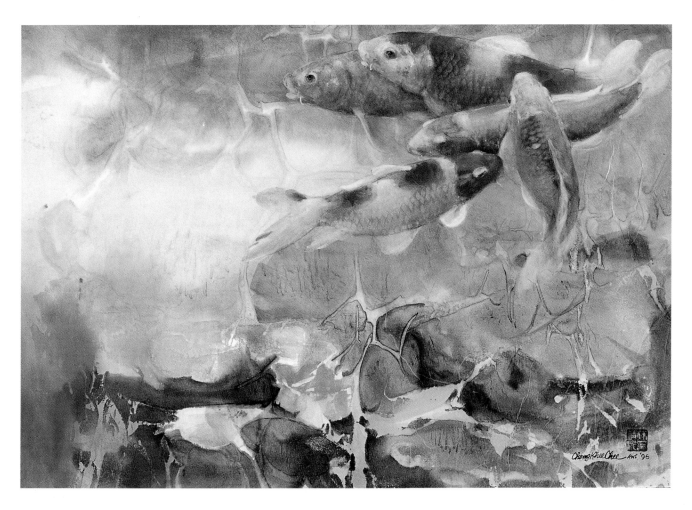

CHENG-KHEE CHEE
Koi Pond
24" x 36" (61 cm x 91 cm)
Chinese Xuan paper
Watercolor with Chinese ink

Koi Pond was accomplished by combining monoprinting and painting processes. The abstract underpainting, suggesting water and lily pads, was improvised by splashing water, Chinese ink, and watercolor on a piece of plastic and transferring the image to a sheet of un-sized Chinese rice paper. After the underpainting was mounted, I decided on koi for the subject matter and the Z-shaped pattern to echo the rhythm of movement. The koi unify the water and lily pads and keep the viewer's eye within the composition.

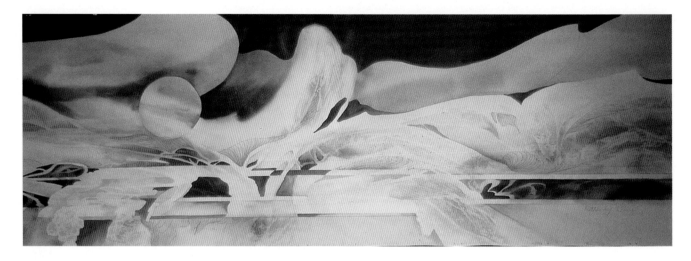

SHIRLEY KRUISE HATHAWAY
Indecisive II
22" x 30" (56 cm x 76 cm)
300 lb. cold press

While my paintings may at first seem non-representational, most of them are based on water, sky movements, waterfalls, and rocks observed during sailing trips. I first devise a composition that establishes this intention, and then deal with issues of color, movement, and texture. I like to pull the viewer into a painting with strong diagonals, and I achieve this by increasing the intensity of the color and the value contrasts at the center of interest. Most of my work projects a feeling of being lost in a vast space.

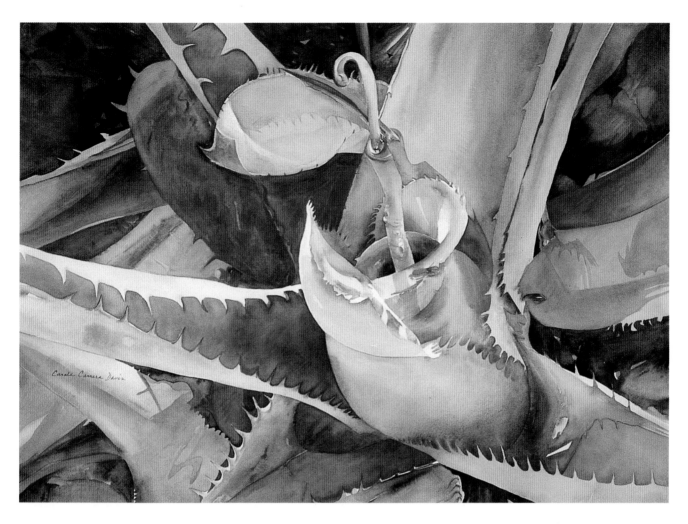

CAROLE CARRERA DAVIS
Aloe IX
22" x 30" (56 cm x 76 cm)
Arches 300 lb. rough

I am constantly searching for bold subjects with high visual impact that give me the opportunity to create dramatic compositions. When I find such a subject, I determine the essential parts and then photograph it. Later, I review the photographs, make quick value sketches of the composition, and begin painting. For *Aloe IX*, I photographed the plant from above to accentuate the dramatic spread of the spines and then transferred it onto the watercolor paper.

IRENE KALLAS
Cornstalk
30" x 22" (76 cm x 56 cm)
Arches 140 lb.

To represent the cornstalk in a new way, I decided to put it in an unusual setting. A long, vertical line needed strong patterns and angled lines to balance the line of the cornstalk. The composition is unified by carefully designed patterns of color, light, and shadows.

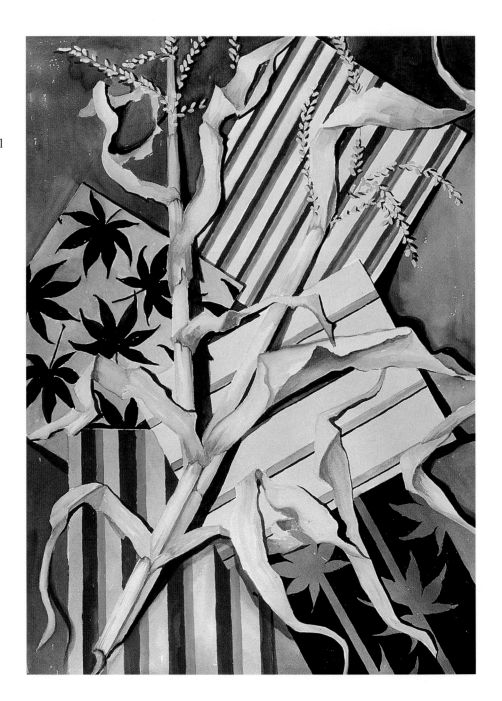

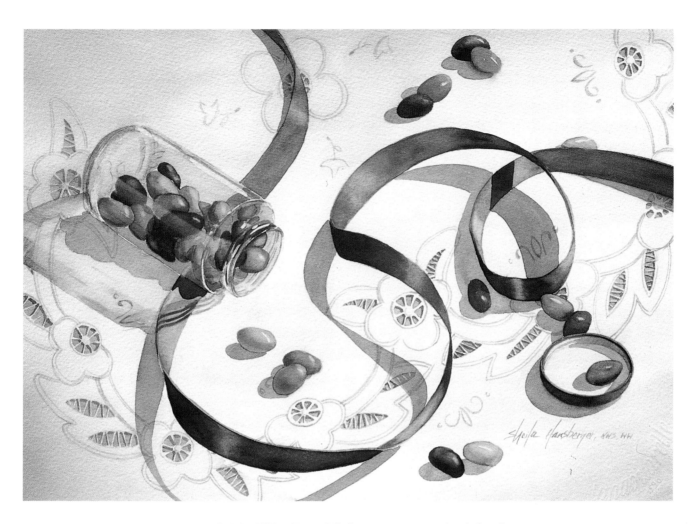

SHEILA HANSBERGER
Blue Ribbon Beans
11" x 15" (28 cm x 38 cm)
Lanaquarelle 140 lb. cold press

In *Blue Ribbon Beans,* jelly beans were grouped and placed at different angles to add variety to their repetitive size and shape. The ribbon is a compositional tool that is used to weave the objects into a pleasing design, while the straight sides of the glass jar help break the monotony of the ribbon's curves. A mostly white background provides a contrasting matte setting for the shiny shapes. Special care was taken to ensure the objects were not equidistant from each other.

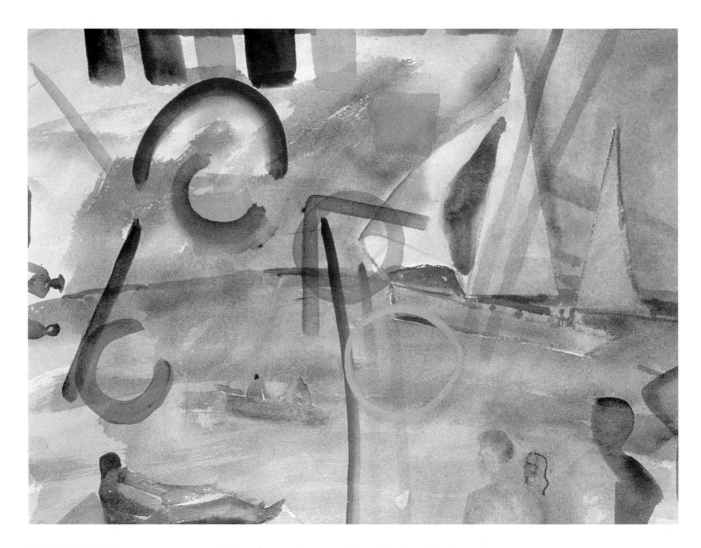

FRANCES HYNES
Monhegan Harbor
22" x 30" (56 cm x 76 cm)
Arches 140 lb.
Watercolor with gouache

Using elements from a variety of photographs of Monhegan Island in Maine, I overlapped figures and landscape in order to suggest a layering of time and to evoke the memory of generations of people who have lived or vacationed on the island. My composition is based not on real time or accurate perspective but, rather, on new approaches that express deeply felt emotions. I used transparent watercolor in areas of the picture where I wanted to suggest the fragility of human existence and opaque gouache where I wanted dense primary colors to express the joy of life.

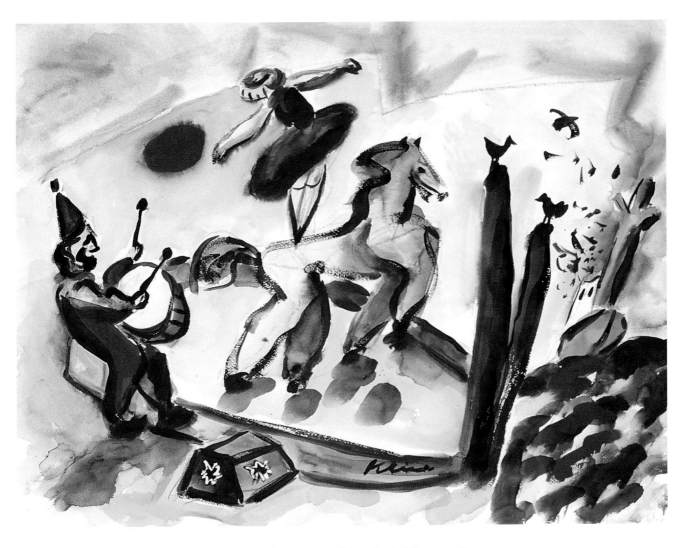

HOWARD KLINE
Circus by the Sea
22" x 30" (56 cm x 76 cm)
Fabriano 160 lb. cold press

I spend much of my time doing classical figure studies so that when I paint I can combine the perspective of an accomplished artist with the sensitivity of a child. My art is about my deep love of God and humanity, and I choose lyrical subjects for the illusion of movement they provide in my compositions.

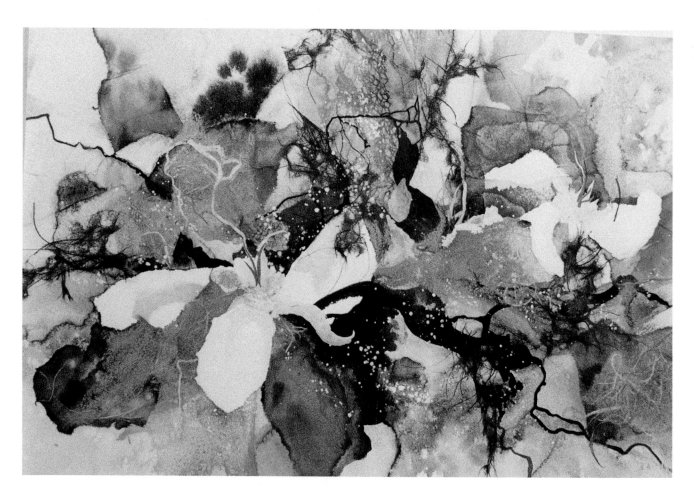

BETTY D. BROWN
Tropical Fantasy
15" x 22" (38 cm x 56 cm)
Saunders Waterford 140 lb. cold press
Watercolor with collage and ink

Even when I am just improvising, I find myself subconsciously creating a design. For *Tropical Fantasy*, many materials–masking tape, wax paper, rice paper, and gauze–were layered on dry paper, sprayed with water, and painted. Once dry, the material was removed, and I applied darker paint, glued on rice paper, and strengthened the movement and design. Watercolor paper was tinted, torn into petal shapes and glued in place. To complete the painting, white bleed-proof ink was spattered on the paper to strengthen lines.

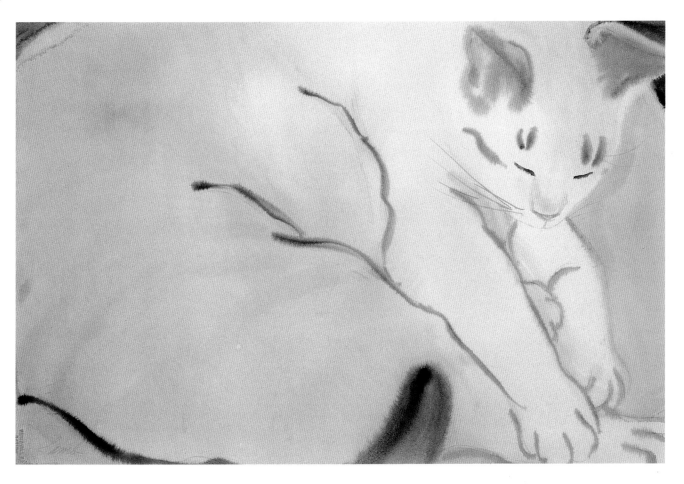

DONNA LAMB
Cat-in-Box
15" x 22" (38 cm x 56 cm)
Arches 140 lb. hot press

Combining the idea of ink drawings with more realistic watercolor paintings, I created *Cat-in-Box*, using watercolor rather than ink for the line drawing. While working on a series of cats in boxes, I decided to use the shape of the paper for the box and have the cat fill the entire space. I have concentrated on painting cats for the past nine years.

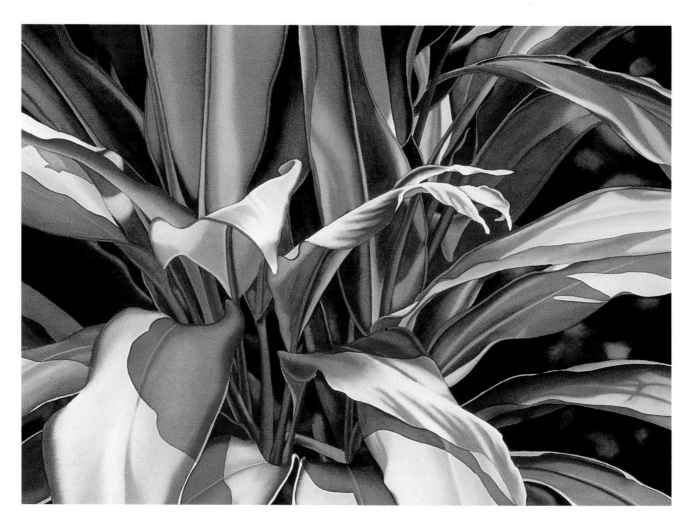

SUSAN McKINNON
Sun Ti
21.5" x 29" (55 cm x 74 cm)
Arches 300 lb. cold press

In *Sun Ti*, the tropical foliage of the Hawaiian ti plant radiates to the outer edges of the painting. I placed the central stalk just off-center and staggered the dark background openings to keep the borders interesting. Depth is indicated through overlapping shapes, cast shadows, and light passages within the dark background. The pointed tips of the leaves, most turned very subtly, create direction and movement within the painting. I find that investing time in drawing and planning stages is time well spent. Initial satisfaction with composition lets me concentrate more fully on applying the paint.

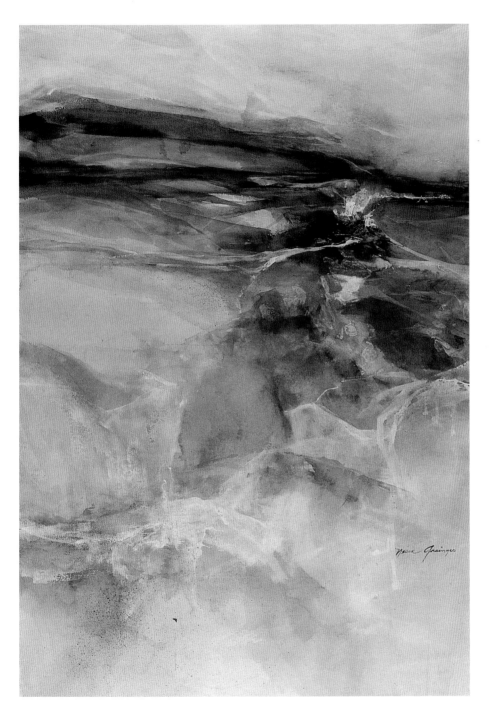

NESSA GRAINGER
Sunset
40" x 28" (102 cm x 71 cm)
Arches 260 lb. cold press
Watercolor with ink

I have long been inspired by the variety of colors, textures, forms, and light of the American Southwest. In *Sunset*, an arroyo-like shape, reinforced by white-ink lines, carries the eye from the foreground to the distant high horizon. Layers of transparent watercolor produce depth and space, the massive rocks are highlighted by white ink, applied with a dry brush after the watercolors have dried. The vastness and drama of the rocky terrain can be sensed by the viewer through the composition.

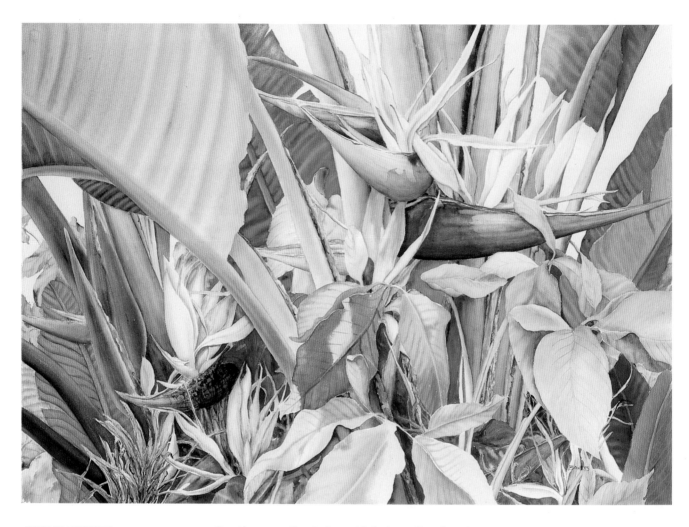

JUNE Y. BOWERS
Birds of Paradise
29.5" x 41" (75 cm x 104 cm)
Arches 555 lb. cold press

Outside my studio window, a bird of paradise plant thrives, presenting a new composition with every change of light. Color and composition have always been of primary interest in my work, and I pick and choose the elements of my subject to represent the most dynamic composition. In *Birds of Paradise*, I utilized the plant's dramatic angles and paths of light and shadow to create a visual path through the painting.

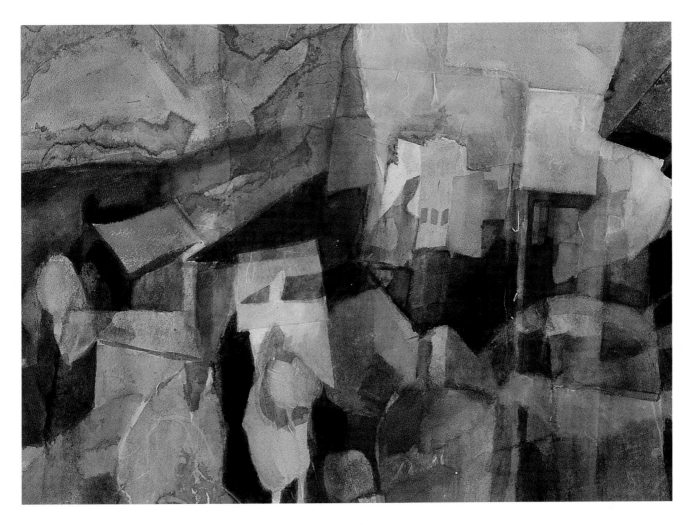

RUTH J. EYRICH
Santo Tomas
15" x 22" (38 cm x 56 cm)
Arches 140 lb. cold press
Watercolor with collage

My creative process evolves from the layering of shapes and the positioning of color. Without a preconceived subject, my primary concern is with compositional design, so when the subject emerges it is on a strong foundation. Flat space is important in my work, but with layers of glazes to suggest an equivocal sensation in the space. Value adjustment and tonal summation complete my process, all of which support successful composition.

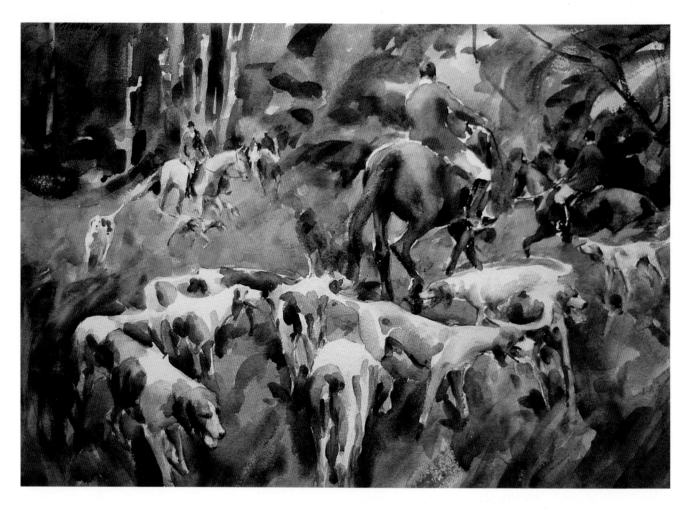

about the authors

BETTY LOU SCHLEMM
Hamilton Hunt
22" x 30" (56 cm x 76 cm)
Arches 140 lb. cold press

BETTY LOU SCHLEMM, *JUDGE*
Betty Lou Schlemm, A.W.S., D.F., has been painting for more than thirty years. Elected to the American Water-color Society in 1964, and later elected to the Dolphin Fellowship, she has served as both regional vice president and director of the American Water-color Society. Schlemm is also a teacher and an author. She has been conducting painting workshops in Rockport, Massachusetts for twenty-nine years. Her book, *Painting with Light*, published by Watson-Guptill in 1978, has remained a classic. She also has recently published *Watercolor Secrets for Painting Light*, distributed by North Light Books, Cincinnati.

SARA M. DOHERTY, *EDITOR*
Sara M. Doherty graduated from Knox College in Galesburg, Illinois and took graduate-level courses in education at Loyola University in Chicago. She has been a teacher and a learning center director, and she has helped organize a number of national art competitions, juried exhibitions, and painting work-shops. She also worked on the production and sale of an art instruc-tion video with the noted watercolorist, Sondra Freckelton. In 1994, Doherty accompanied a group of artists and art lovers to Italy and reported on the workshop in an article published in *American Artists* magazine.

directory of artists

Melissa Adkison 114
19 Andreas Circle
Novato, CA 94947

Melva I. Allen 16
21942 Ustick Road
Caldwell, ID 83605

Mary Ellen Andren 73
8206B Willowbrook Circle
Huntsville, AL 35802

Joanne Augustine 88
P.O. Box 412
Rocky Hill, NJ 08553

Nancy L. Baldrica 123
3305 Brenner Place
Colorado Springs, CO 80917

Carmen Newman Bammert 47
9116 Buffalo Court
Flushing, MI 48433

Sabine M. Barnard 100
1722 S. Delaware Place
Tulsa, OK 74104

Sandra E. Beebe 25
7241 Marina Pacifica Drive S
Long Beach, CA 90803

Henry Bell 64
150 N. Millcreek Road
Noblesville, IN 46060

Avie Biedinger 99
6158 Kaywood Drive
Cincinnati, OH 45243

Stephen M. Blackburn 92
410 Chamberlin Drive
South Bend, IN 46615

Jorge Bowenforbés 19
P.O. Box 1821
Oakland, CA 94612

June Y. Bowers 140
919 Krueger Parkway
Stuart, FL 34996

Betty Braig 72
5271 S. Desert Willow
Gold Canyon, AZ 85219

Jackie Brooks 95
2920 Queen Anne North
Seattle, WA 98109

Jim Brower 112
2222 Grecourt Drive
Toledo, OH 43615-2918

Betty D. Brown 136
P.O. Box 254
Carlton, MN 55718-0254

Alan John Bruce 102
2-1847 Crescent Road
Victoria, BC V8S 2G7
Canada

Barbara K. Búer 76
5438 Oxford Drive
Mechanicsburg, PA 17055

Dan Burt 35
2110-B West Lane
Kerrville, TX 78028-3838

Ralph Bush 66
55 Mt. Pleasant Street
Rockport, MA 01966

Hwang Nam Chang 58
109 Franklin Street
Newark, NJ 14513

Cheng-Khee Chee 129
1508 Vermilion Road
Duluth, MN 55812

Anna Chen 61
691 Bear Creek Court
Winter Springs, FL 32708

Alfred Christopher 103
413 Hopewell Avenue
Aliquippa, PA 15001

Judi Coffey 37
10602 Cypresswood Drive
Houston, TX 77070

Robert E. Conlan 40
35-25 212th Street
Bayside, NY 11361

Charlotte Cornett 57
6306 Glendora
Dallas, TX 75230

Laurel Covington-Vogl 60
333 Northeast Circle
Durango, CO 81301

Elaine M. Cusmano 26
6432 Glyndebourne
Troy, MI 48098

David R. Daniels 91
8012 Piney Branch Road
Silver Spring, MD 20910

Carole Carrera Davis 131
567 Hickory Hill Circle
Blacksburg, VA 24060

K. Dawson 69
505 Summer Street
Eau Claire, WI 54701

Pat Deadman 28
105 Townhouse Lane
Corpus Christi, TX 78412

Brad Diddams 70
1210 W. Tulane Drive
Tempe, AZ 85283

Ellen Jean Diederich 87
3374 Maplewood Court
Fargo, ND 58104

H. C. Dodd 8
1749 South Boulevard
Houston, TX 77098-5419

Claire V. Dorst 128
618 NW High Street
Boca Raton, FL 33432

Evalyn J. Dyer 54
6041 Worrell Drive
Fort Worth, TX 76133

Caroline A. England 39
2950 Crestline Drive
Davenport, IA 52803

Deborah Kaplan Evans 6
23622 Via Navarra
Mission Viejo, CA 92691

Ruth J. Eyrich 141
2408 Daneland Street
Lakewood, CA 90712

Manette Fairmont 59
278 Todd Avenue
Sonoma, CA 95476

Renée Fakhrai 119
1102 Orchard Road
Lafayette, CA 94549

Jack Flynn 90
3605 Addison Street
Virginia Beach, VA 23462

Glenda K. Folk 124
8637 E. Gail Road
Scottsdale, AZ 85260

Frank Francese 96
1771 Stellar Place
Montrose, CO 81401

Michael Frary 81
3409 Spanish Oak Drive
Austin, TX 78731

Alfred B. Fuhrmann 111
1300 N. Green Meadows Blvd
Streamwood, IL 60107-1138

Henry Fukuhara 85
1214 Marine Street
Santa Monica, CA 90405

Lynn Gadal 115
3648 Coolidge Avenue
Los Angeles, CA 90066

Dorothy Ganek 43
125 Rynda Road
South Orange, NJ 07079

Marsha Gegerson 31
10241 NW 48th Court
Coral Springs, FL 33076

Jean K. Gill 127
2872 Spring Chapel Court
Herndon, VA 20171

Molly Davis Gough 104
3675 Buckeye Court
Boulder, CO 80304

Joyce Grace 94
3403 Stonewall Road
Jackson, MI 49203

Nessa Grainger 139
212 Old Turnpike Road
Califon, NJ 07830

Joseph E. Grey II 13
19100 Beverly Road
Beverly Hills, MI 48025-3901

Marilyn Gross 48
374 MacEwen Drive
Osprey, FL 34229

Gerry Grout 20
57 Biltmore Estates
Phoenix, AZ 85016

Philip Gurlik, Jr. 49
4115 Markham
Houston, TX 77027

Helen Gwinn 55
608 W. Riverside
Carlsbad, NM 88220

Robert Hallett 52
30002 Running Deer Lane
Laguna Niguel, CA 92677

Nancy Handlan 36
6708 Windingwood Lane
Wilmington, NC 28405

Sheila Hansberger 133
P.O. Box 1181
Yucaipa, CA 92399

Audrey H. Harkins 107
15085 Nola
Livonia, MI 48154

Shirley Kruise Hathaway 130
30583 J. Carls
Roseville, MI 48066

Anne Hayes 67
7505 River Road #11G
Newport News, VA 23607

Phyllis Hellier 12
2465 Pinellas Drive
Punta Gorda, FL 33983

Allan Hill 71
2535 Tulip Lane
Langhorne, PA 19053

Jane R. Hofstetter 42
308 Dawson Drive
Santa Clara, CA 95051

Joey Howard 84
277 East Tuckey Lane
Phoenix, AZ 85012

Carol Hubbard 29
574 Cutler's Farm
Monroe, CT 06468

Frances Hynes 134
55 E. Deerwood Road #202
Savannah, GA 31410

Joe Jaqua 45
300 Stony Point Road #192
Santa Rosa, CA 95401

Edwin L. Johnson 68
7925 N. Campbell Street
Kansas City, MO 64118-1521

Zetta Jones 30
105 N. Union Street #6
Alexandria, VA 22314

Jane E. Jones 46
5914 Bent Trail
Dallas, TX 75248

Irene Kallas 132
17734 W. Outer Drive
Dearborn Heights, MI 48127

Joyce H. Kamikura 32
6651 Whiteoak Drive
Richmond, BC V7E 4Z7
Canada

Sandy Kinnamon 126
3928 New York Drive
Enon, OH 45323

Howard Kline 135
50 Main Street
Rockport, MA 01966

Priscilla E. Krejci 21
4020 Fiser
Plano, TX 75093

Lynne Kroll 10
3971 NW 101 Drive
Coral Springs, FL 33065

Chris Krupinski 117
10602 Barn Swallow Court
Fairfax, VA 22032

Donna Lamb 137
422 E. Main, Suite 163
Nacogdoches, TX 75961

Hal Lambert 77
32071 Pacific Coast Highway
South Laguna, CA 92677

Harold Larsen 105
400 Estrella Court
Santa Fe, NM 87501

John A. Lawn 121
200 Hulls Highway
Southport, CT 06490

Ara Leites 113
168 Oxford Way
Santa Cruz, CA 95060

Douglas Lew 23
4382 Browndale Avenue
Edina, MN 55424

Susan Luzier 97
1429 S 3rd
Aberdeen, SD 57401

Diane Maxey 44
7540 N Lakeside Lane
Paradise Valley, AZ 85253

Jackie May 116
221 Nicollet Avenue
North Hankato, MN 56003

Susan McKinnon 138
2225 SW Winchester
Portland, OR 97225

Joanna Mersereau 22
4290 University Avenue
Riverside, CA 92501

Edward Minchin 122
54 Emerson Street
Rockland, MA 02370

Ann Mitchell 41
28142 Sunset Drive
Bonita Springs, FL 34134

Lance R. Miyamoto 120
53 Smithfield Road
Waldwick, NJ 07463

Ellen Murray 108
7109 S Stanley Place
Tempe, AZ 85283

John A. Neff 80
17 Parkview Road
Wallingford, CT 06492

Diane J. O'Brien 118
17135 Beverly Drive
Eden Prairie, MN 55347

Jane Oliver 75
20 Park Avenue
Maplewood, NJ 07040

Gloria Paterson 3, 34
9090 Barnstaple Lane
Jacksonville, FL 32257

Kathleen Pawley 83
411 Creason Court #205
Louisville, KY 40223

Joan M. Plummer 98
10 Monument Hill Road
Chelmsford, MA 01824

John Pollock 110
1009 Nutter Boulevard
Billings, MT 59105

Elizabeth Hayes Pratt 33
Box 238
Eastham, MA 02642

Lorraine Ptacek 18
791 Chatham Avenue
Elmhurst, IL 60126

Roxanne Reep 125
P.O. Box 8303
Greenville, NC 27835

Pat Safir 11
521 Corona
San Antonio, TX 78209

J. Luray Schaffner 63
14727 Chermoore Drive
Chesterfield, MO 63017-7901

Michael Schlicting 7
3465 NE Davis Street
Portland, OR 97232

Betty Lou Schlemm 144
Caleb's Lane
Rockport, MA 01966

Patricia Scott 51
743 - 24th Square
Vero Beach, FL 32962

Barbara Scullin 106
128 Paulison Avenue
Ridgefield Park, NJ 07660

Morris J. Shubin 53
313 N. 12th Street
Montebello, CA 90640

Donna Shuford 17
716 Water Oak Drive
Plano, TX 75025

Edwin C. Shuttleworth 50
3216 Chapel Hill Boulevard
Boynton Beach, FL 33435

Patsy Smith 79
821 Apache Drive
North Platte, NE 69101

Susan Spencer 89
306 Gordon Parkway
Syracuse, NY 13219

Shirley Sterling 78
4011 Manorfield Drive
Seabrook, TX 77586

Donald Stoltenberg 74
947 Satucket Road
Brewster, MA 02631

Betty M. Stroppel 24
115 Sweet Briar Lane
North Plainfield, NJ 07060

Betsy Dillard Stroud 101
1412 E. Rosemonte Drive
Phoenix, AZ 85024

Anne D. Sullivan 56
28 Rindo Park Drive
Lowell, MA 01851

Nancy Swindler 38
6953 S 66th E. Avenue
Tulsa, OK 74133-1747

Dean Teague 109
P.O. Box 96
Mt. Vernon, TX 75457

Susan Webb Tregay 9
470 Berryman Drive
Snyder, NY 14226

Judy D. Treman 93
1981 Russell Creek Road
Walla Walla, WA 99362

Donna Watson 82
19775 SW Taposa Place
Tualatin, OR 97062

Mary Weinstein 27
P.O. Box 2366
27867 Peninsula Drive North
Lake Arrowhead, CA 92352

Murray Wentworth 15
132 Central Street
Norwell, MA 02061

Joyce Williams 62
Box 192
Tenants Harbor, ME 04860

Douglas Wiltraut 65
969 Catasauqua Road
Whitehall, PA 18052

Eudoxia Woodward 86
24 Kenmore Road
Belmont, MA 02178

Elena Zolotnitsky 14
205 Duke of York Lane, Apt. T2
Cockeysville, MD 21030

glossary

analogous colors: the shades, tints, or tones of any three colors that are next to each other on the color wheel

background: the part of the painting that appears to be farthest from the viewer

balance: the even distribution of shapes and colors in a painting

bristol board: a stiff, durable cardboard made in plate and vellum finishes with thicknesses of one- to four-plies

cold press paper: paper with a medium-rough texture as a result of being pressed with cold weights during processing

collage: process of constructing flat (or low relief) two-dimensional art by gluing various materials (i.e. newspaper, photographs, etc.) onto the painting surface

complementary colors: any two colors that are opposite each other on the color wheel (i.e., red and green) which create a high contrast when place side by side

contrast: the juxtaposition of extremes within the composition—in colors (purple with orange), values (white with black), textures (coarse with smooth), etc.

crayon resist: a technique in which crayon is applied to the surface and repels the paint that is applied afterward

crosshatching: brushstrokes applied at right angles to each other to create contrasting tone and density

dapple: to mark or patch with different shades of color

drybrush: a method of ink or watercolor painting in which most of the pigment has been removed from the brush before application

foreground: the part of the painting that appears to be closest to the viewer

gesso: a paste prepared from mixing whiting with size or glue and spread upon a surface to fit it for painting or gilding

gouache: a method of painting with opaque colors that have been ground in water and mingled with a preparation of gum

hot press paper: paper with a smooth surface as a result of being pressed between calendar rollers that flatten the grain into an even finish

hue: the actual color of anything—also used to describe what direction a color leans toward, (i.e. bluish-green, etc.)

illustration board: layers of paper adhered to a cardboard backing to produce a sturdy drawing surface, made in various thicknesses and textures

local color: the true color of an object seen in ordinary daylight

museum board: available in two- and four-ply, this soft, textured surface absorbs wet or dry pigment readily; usually used in archival malting and framing of artwork.

saturation: the intensity or brightness of color

shade: the color achieved when black is added to a hue

spatter: to scatter color on the canvas by splashing on paint

stipple: to create an optical mix of colors through the use of dots or dashes

tint: color achieved when white or water is added to a hue

tooth: refers to the depth of the grain of paper

value: the relative lightness or darkness of a color

vellum: a smooth, cream-colored paper resembling calfskin

wash: a thin, usually transparent coat of paint loosely applied to the surface of the canvas